TERENURE

T0323277

JOE CURTIS

First published 2014
Reprinted 2015, 2021

The History Press
97 St George's Place, Cheltenham,
Gloucestershire GL50 3QB
www.thehistorypress.co.uk

British Library Cataloguing in Publication Data.
A catalogue record for this book is available from the British Library.

ISBN 978 1 84588 821 3

Typesetting and origination by The History Press
Printed by TJ Books Limited, Padstow, Cornwall

CONTENTS

ACKNOWLEDGEMENTS

Grateful thanks to: Paul Ferguson, Olga Cripps, Mark Downey, Bishop Pat Granahan, Val and Betty Kerrigan, Sally Walker, George Stuart, Jim Kilroy and Michael Corcoran, Christy Harford, Sile Coleman, Revd Ted Woods and Revd Anne Taylor, Fr Frank McDonnell, Fr Eoin Moore, Tom Canaty and Sue Barber, Norah Price, Deirdre Smyth, Deirdre Coughlan and Catriona Carney (Presentation School), Declan Donnelly, Jeanne Kennedy, Joan Smith, Joe Katz, Ellen Murphy, Audrey Shiels, Una Fletcher, Manning Contractors, The Terenure Inn, Brady's, The Eagle House, Bank of Ireland, Sherry Fitzgerald, Cronin & Co., Terenure Enterprise Centre, Bill Sheehan, Terenure Synagogue, Rathmore Villas Synagogue, St Joseph's Church, St Joseph's National School, Our Lady's School, Terenure College, Terenure College Rugby Football Club, Presentation School, Presentation College, Zion National School, CYMS, VEC, and all who allowed me to take photos, escorted me around their premises, told me their story, or assisted in numerous ways.

Thanks also to the excellent staff at the National Library, National Archives, Irish Architectural Archive, Office of Public Works, Valuation Office, Central Catholic Library, Dublin City Library and Archives, Terenure Library, South Dublin County Council Library, Irish Labour History Museum, Gort Muire Carmelite Library, Howth Transport Museum, Diocesan Archives.

Where photos are not acknowledged, they were taken by the author.

INTRODUCTION

The first mention of Terenure townland is generally reputed to date from 1216, when Hugh de Barnewall was granted the lands of Terenure and Kimmage. The William Petty Survey (Down Survey) in the 1650s, after the Cromwellian War, recorded the townland of 'Tirenure', owned by Peter Barnwell, and which was part of the parish of 'Rafarnam', having 327 acres, with a castle in good repair, and a dwelling house, formerly a mill. The castle is marked on the map as Rathfarnham Castle, and the house may have been the site of Terenure House (later to become Terenure College).

Terenure centred around Terenure House, and not around the present Rathfarnham Road crossroads. It is reputed that the Templeogue Road was privately built in 1801, linking these crossroads to Templeogue. A tollhouse was constructed near the north end of the new road, collecting tolls from travellers entering the city. The tollhouse was built at an angle of 45 degrees to the road, affording a good view in the direction of Templeogue. Later, the tollhouse became a police station, and is now a private house, although extended over the years.

A circle of two-storey cottages was built near the Rathfarnham Road crossroads, and thereafter, this double traffic junction was known as Roundtown. Around 1868, the Roundtown name was changed to Terenure. The present Bill Sheehan & Sons car showrooms (previously Rathdown Motors) is the only survivor of the original circle of cottages – if you look carefully, you can see that the front and back walls have a slight curve.

The older parts of Terenure are mostly mid-Victorian, followed by some Edwardian, while more modern housing estates date from the interwar period.

The Terenure district was governed by South Dublin Rural District Council, and in 1930 came under the control of Dublin Corporation (now called Dublin City Council).

Nowadays, Terenure is full of cafés, restaurants and pubs, a bustling metropolitan suburb on the edge of Dublin city.

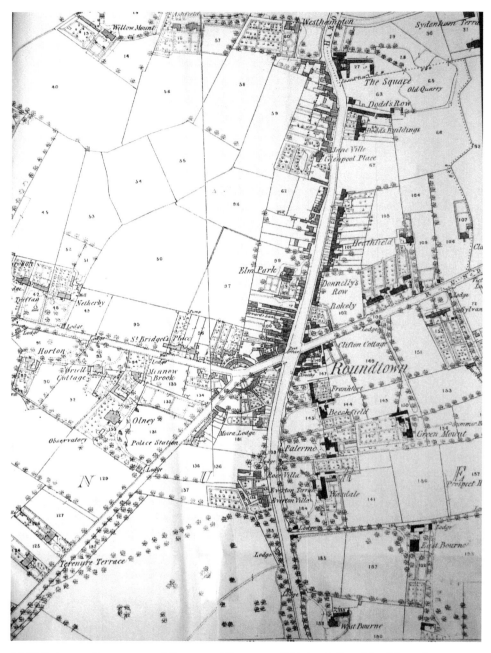

1865 Ordnance Survey map of Terenure. (Courtesy of Trinity College Map Library)

1

EDUCATION

TERENURE COLLEGE

The Carmelite Fathers opened this famous boys' school in 1860, with an initial enrolment of twenty-one boarders, and known as the College of Our Blessed Lady of Mount Carmel. Nowadays this order of priests is more associated with their church in Whitefriar Street.

The Down Survey maps of the 1650s show a house (formerly a mill), which seems to be the site of Terenure House. Rocque's map of 1760 shows Terenure House. However, the present house is reputed to date from around 1789, at which time the original house was either rebuilt or substantially altered. The landholding was originally in the possession of Hugo de Barnwell in the thirteenth century, followed by Richard Talbot, Joseph Deane, Robert Shaw, Henry Taffe, Fred Bourne (who formed the artificial lake, which is still enjoyed today), and finally Alexander Hall, who sold the house and 40 acres to the Carmelites in 1859.

Bentley & Son were the auctioneers in 1859, and their brochure makes interesting reading. The ground floor contained a dining room and a drawing room, each 30 feet by 27 feet, with ante-rooms, each 17 feet by 16 feet. The kitchen was behind the dining room, and above this was a large ballroom. The first floor had two very large bedrooms, two small bedrooms, a bathroom, and servants' bedroom. The attic storey had five family bedrooms (including a large nursery, two rear bedrooms, and a stone staircase to the roof). Lighting was by means of gas, including a gasometer in the yard, and there was a pumped water supply. The grounds included a walled kitchen garden, vinery and peach house. The gardens and lawns were separated from the rest of the land by a 'ha-ha', or sunken fence, meaning that the fields were at a lower level than the lawns.

An extension to the east of the old house was constructed by the Carmelites in 1877, followed by another red-bricked extension in 1894, the latter used as the monastery and chapel. The adjoining flat-roofed concert hall, with some classrooms overhead, dates from 1947, and includes the famous entrance lobby known as the 'Crush Hall'. The hall has been re-named the 'Donal McCann Theatre'. The new

chapel and monastery opened in 1957. In recent decades, many other extensions have been added, including the swimming pool in the 1970s (it was open-air for the first few years!).

Quite unexpectedly, the school closed in 1909, and became the novitiate for the priests. Thankfully, the school re-opened in 1917.

The priests ran the adjoining farm until the 1970s, thereby obtaining all their milk and vegetables. The school always had more day pupils than boarders, and the latter were phased-out in the early 1970s.

Rugby is a favourite sport, but the college is also active in soccer, cricket, Gaelic football, swimming, and tennis. Chess, and the annual play (in conjunction with Our Lady's Girls' School), are other activities.

Nowadays there are around 800 primary and secondary pupils, taught by about seventy-five teachers, mostly lay people, although a few priests remain. Some of the facilities are open to the public, such as the chapel and the swimming pool. The former originally had the sanctuary at the north end (although by convention should face east to the Holy Land), but the altar is now in the centre, and the old sanctuary is the Lady Chapel, for special occasions.

No article about the college would be complete without referring to the Terenure College Rugby Football Club, which was started by the Past Pupils Union in 1940. The adjoining Lakelands Park was donated by the college, and a pavilion was built in 1947 (the present clubhouse dates from 1962). The original black shorts, and purple, black and white jerseys, are still sported. Father Corbett was the first president, and Hugh Milroy was the first captain. The 2014 President is Brian Colgan, whose son, Kevin, played on the highly regarded Junior Cup-winning Terenure team of 2010.

OUR LADY'S SECONDARY SCHOOL

The three-storey over-basement house was built around 1700 by Arthur Bushe, who sold it to John Hobson in 1772, who in turn sold it to Abraham Wilkinson in 1781. Wilkinson gave the house and demesne as a dowry to his only daughter, Maria, when she married Sir Robert Shaw of adjoining Terenure House, in 1796. Thereafter, Bushy Park House was the seat of the Shaw family in Terenure. The family were famous in Dublin as bankers (Shaws Bank was located at 3/4 Foster Place) and merchants. Memorials to the family can be seen near the altar in Rathfarnham Anglican church.

Bushy Park House and demesne, including Rose Hall and Springfield, were sold by Sir Robert de Vere Shaw to Dublin Corporation (nowadays called Dublin City Council) in 1953, for £15,000. At the instigation of Archbishop McQuaid, the house and a substantial parcel of land were immediately sold on, for £5,700, to the Congregation of Christian Education – French nuns – to become their first girls' school in Ireland.

The nuns used Bushy Park House as their convent, presided over by Mother Helen Horan in the green habit and veil, and in 1954 built a new single-storey primary school alongside, including the central arch and statue of Our Lady.

In 1992, the nuns sold back part of the land (3.85 acres) to Dublin Corporation, for £12,000, comprising overgrown woods to the south of the convent, which were added to Bushy Park for public use.

The present school has been greatly extended over the decades, and is now a first-class facility, with the best in computer labs, science labs, domestic economy kitchens, concert hall, study hall, library and oratory, catering for about 727 girls, with 52 teachers. The art teacher, Ray Byrne, painted lovely murals on many inside walls.

During the Celtic Tiger in 2000, the nuns sold off the convent/Bushy Park House and 7 acres to Sheelin McSharry, for £14.175 million, and the developer built numerous blocks of apartments, and also three large houses for the nuns. The original convent, now a Protected Structure, lies empty, waiting for the next 'Tiger'. The school is still going strong, although shares the entrance driveway with the numerous residents. At the time of the sale there were only seven nuns living in the big convent: Kathleen Bourne, Mary Kate Shannon, Rosemary Alexander, Elizabeth Byrne, Cara Nagle, Rosemary Magnier, and Josephine Shannon.

The nuns also ran Clermont Boarding School in Rathnew, County Wicklow, which closed in 2005.

PRESENTATION CONVENT PRIMARY AND SECONDARY SCHOOL

Nano Nagle founded the Presentation nuns in Cork in 1775, and they proceeded to open other convents and schools throughout Ireland. Richmond Road in Fairview started in 1820, and a three-storey over-basement school followed. The Daughters of Charity of St Vincent de Paul acquired the nearby house called 'Richmond' in 1857, as a mental asylum, but the Presentation nuns did not like the screaming from the hospital, and sold their convent and school to the Daughters in 1866, for conversion into St Vincent's Female Asylum, which is nowadays called St Vincent's Hospital Fairview. That same year (1866) the Presentation nuns moved, and bought 'Netherby' on Terenure Road West, and immediately added red-bricked extensions at both ends. At the same time they set up St Joseph's Girls National School in the rear coach-house, charging one penny a week, although some poor children were admitted free. The single classroom was 45 feet by 23 feet, and had eight long desks, for 104 children. School was from 10 a.m. to 3 p.m., with one hour for religion every day, all run by Mrs Hickey (a nun), assisted by three young lay-teachers and four monitors (older pupils). The salaries were paid by the government. Within a few years, the government was also paying £14 per year for an Industrial Teacher, 22-year-old Mary Sheridan, who taught plain and fancy needlework, with the produce given to the poorer children at Christmas time. Marianne Ennis replaced her after a few years.

In 1889, the Board of Works (Government) designed a new red-bricked school to accommodate 400 children, to be called St Joseph's, both floors having a large classroom, 48 feet by 25 feet, and a smaller classroom, 22 feet by 18 feet (four classrooms in total), with the roof trusses visible on the first floor. The Trustees of the new school included the Archbishop of Dublin, the parish priest, Mrs Anna Flannery, and Mrs Sherlock, the latter two being nuns. The government paid two-thirds of the total cost of £2,163, and the parents paid the other one-third. The finished layout and appearance was not exactly the same as the Board of Works' design.

In 1903, the school was extended eastwards, to provide, a cookery and laundry instruction room, 30 feet by 19 feet, a classroom, 24 feet by 24 feet, a science room,

24 feet by 24 feet, a toilet, a cloakroom, a lumber room, and a coalhouse, at a total cost of £1,199, with the government paying the usual two-thirds. At that stage, a new staircase was also built, because the original one was considered totally inadequate.

A ten-roomed two-storey extension was added in 1939, at right-angles to the main building. In 2009, a large rear extension was added to the north-west corner of the site.

The secondary school was started by the nuns in 1968 (the year after free Secondary education was introduced by the government), initially in prefabs, and then the present school was built in the 1970s, and transferred to the VEC (Vocational Education Committee) in 2004, with a name-change to Presentation College. The VEC is now known as City of Dublin Education & Training Board (CDETB).

The convent and internal chapel, on a site of 1.26 hectares (over 3 acres), were sold by the nuns (Ellen Hanlon, Anita Switzer and Elizabeth Grant) to a developer in 2006 for €31.55 million, and then demolished by the developer later in the year. The Celtic Tiger died suddenly, and the site now lies derelict. All the nuns have now dispersed to other convents. The auctioneers brochure refers to three reception rooms in the convent, a dining room, kitchen, and chapel, all on the ground floor, and twenty-one bedrooms and seven offices on the first floor, with a combined area of 800m² (8,500 square feet). To this day, it is a mystery why the council did not List such an important part of our heritage.

The nun's small rear cemetery was excluded from the sale, and is presently landlocked. The central limestone high cross was a gift in 1871 from the poor children of the Richmond Road School, Fairview (by that date converted into a mental hospital). The nuns now have a new burial plot in Newlands Cross Cemetery. Their cemetery in Fairview still holds seventeen Presentation nuns, including Mother Mary Xavier Doyle (died aged 100 in 1857), shared with thirty-nine Daughters of Charity.

ST JOSEPH'S BOYS NATIONAL SCHOOL

The 1837 Ordnance Survey map shows a School House at the present 55 Terenure Road North, opposite the present Dispensary/Health Centre.

In 1866, the Catholic parish priest built Roundtown Boys National School on Terenure Road East, with a chapel-of-ease attached to the side, all in granite, with a slated roof. The name, St Joseph's, had already been allocated to the girls' convent school on Terenure Road West. The single classroom measured 66 feet by 22 feet.

The first master was Daniel Farrelly, aged 25, in charge of about 150 boys. There were twelve long desks, each capable of seating twelve boys. A fireplace at the east end provided heat in winter.

When the new church opened in 1904, the former chapel-of-ease (66 feet long, plus a timber extension of 50 feet) became extra classrooms for the boys. The name, St Joseph's, was substituted for Roundtown National School about a decade later.

The school was rebuilt in 1972, extended later, and recently enlarged by adding two-storey prefabs, to accommodate the present 500 boys and 20 teachers. Prior to the 1972 rebuilding, there were about 550 boys on the rolls, in 11 classrooms, with 11 teachers.

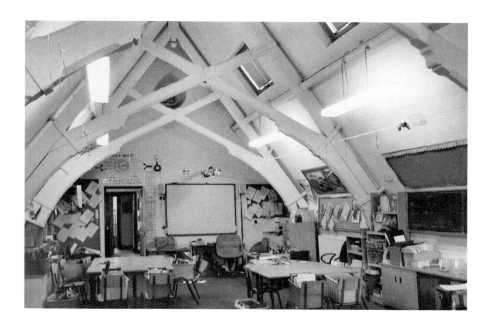

The new first-floor classroom of Zion National School has brought the pupils closer to the 'scissor-type' roof trusses.

ZION NATIONAL SCHOOL

This co-educational school on Bushy Park Road started in 1863, two years after the adjoining Anglican church opened. The former schoolmaster's house is to the rear, and likewise the church sexton's house, both now leased. The 1961 rear concert hall is shared between church and school. The homely school now has an average of 115 boys and girls, including an occasional Catholic or Jew.

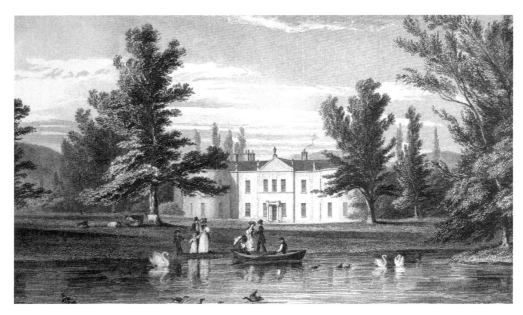

1832 sketch of Terenure House by George Petrie. Now part of Terenure College. (Courtesy of the National Library of Ireland)

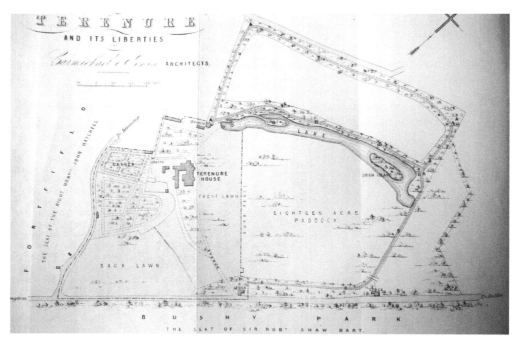

Part of the brochure from Bentley Auctioneers, 1859, for the sale of Terenure House and demesne. Today the two lower fields comprise Terenure College, and the top field is used by Terenure College Rugby Football Club. (Courtesy of the National Library of Ireland)

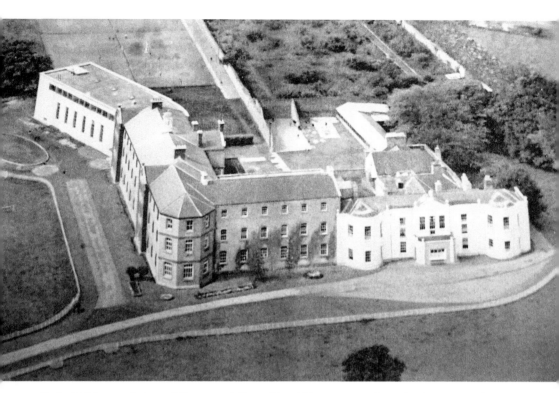

Early 1950s aerial view of Terenure College. The old house is on the right. (Courtesy of Gort Muire Carmelite Library)

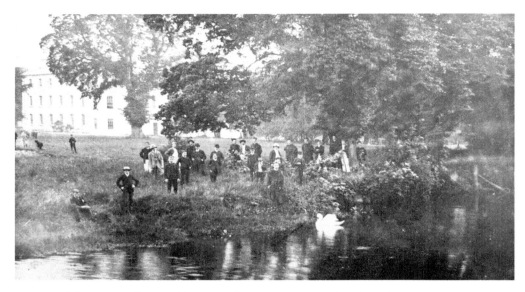

Terenure College around 1890. (Courtesy of Gort Muire Carmelite Library)

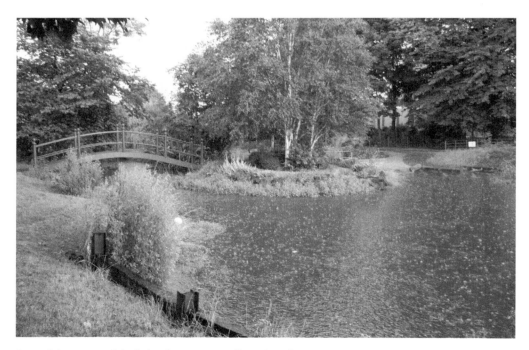

Part of the present lake behind Terenure College chapel.

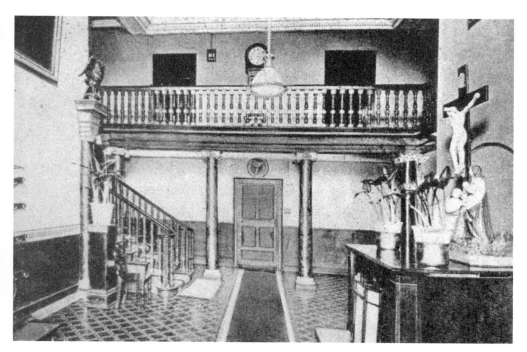

The entrance hall of Terenure College in 1960. (Courtesy of Gort Muire Carmelite Library)

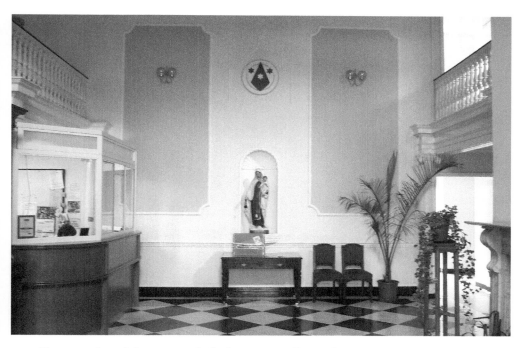

The same view of the entrance hall of Terenure College today.

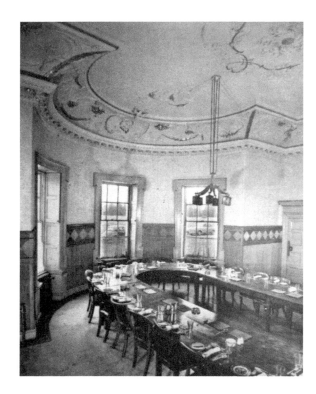

The priest's dining room in Terenure College in 1957. (Courtesy of Gort Muire Carmelite Library)

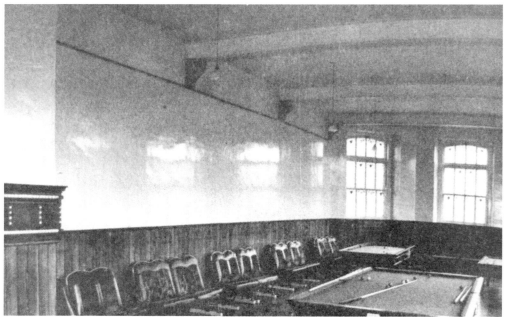

The boys' recreation room in Terenure College in 1959, where billiards and chess were popular. (Courtesy of Gort Muire Carmelite Library)

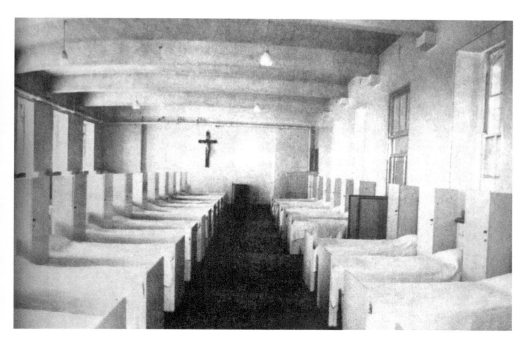

The boys' dormitory in Terenure College in the 1950s. No doubt ghost stories were relished! (Courtesy of Gort Muire Carmelite Library)

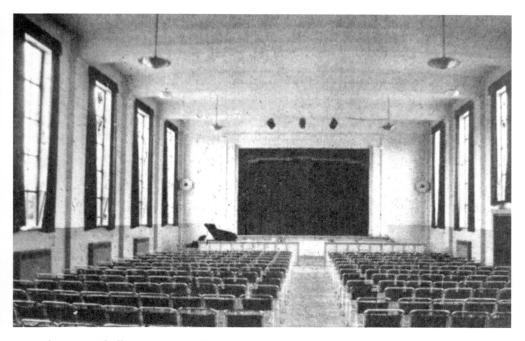

The concert hall in Terenure College in the 1950s. (Courtesy of Gort Muire Carmelite Library)

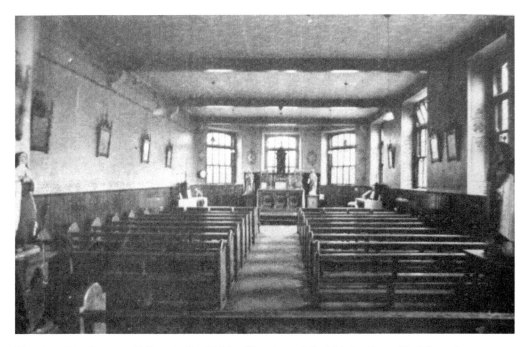

The chapel in Terenure College in the 1950s. (Courtesy of Gort Muire Carmelite Library)

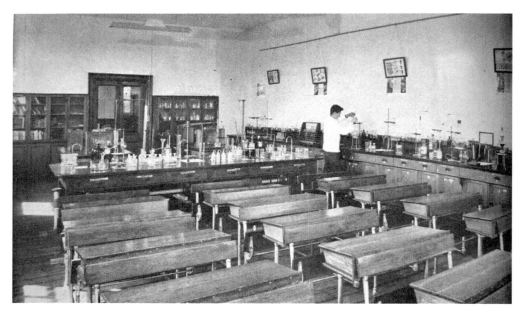

The science lab in Terenure College in the 1950s. (Courtesy of Gort Muire Carmelite Library)

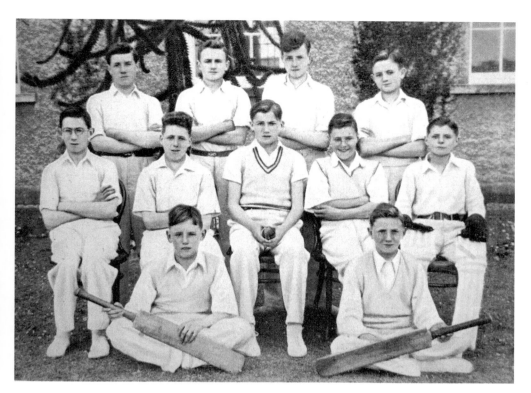

The Junior Cricket XI, 1948. From left to right, front row: D. Doyle, A. Fitzpatrick. Middle row: D. Wheeler, C. Weakliam, G. McCaffrey, R. Kinneen, R. Fallon. Back row: A. McDonald, M. O'Keefe, E. O'Nolan, C. Collier. (Courtesy of Gort Muire Carmelite Library)

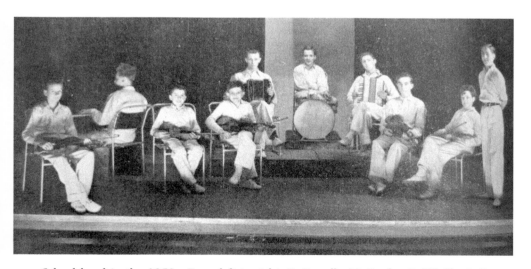

School band in the 1950s. From left to right: R. Farrelly, M. Pender, J. O'Reilly, S. Byrne, R. Coade, F. McCann, A. Brennan, P. Conlon, J. McNamara, J. Cahill. (Courtesy of Gort Muire Carmelite Library)

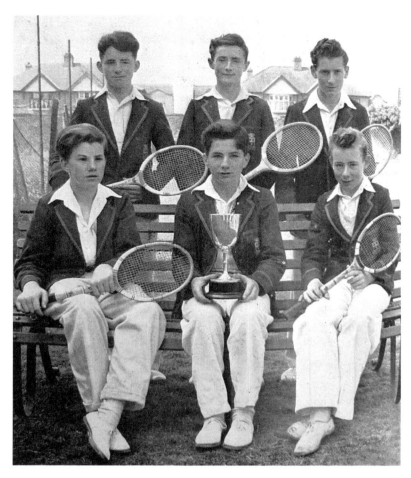

Junior tennis champions, Leinster Secondary Schools, 1949. From left to right, front row: F. Doyle, K. Mulvany (Captain), M. Pender. Back row: S. Connolly, G. Byrne, J. O'Connor. (Courtesy of Gort Muire Carmelite Library)

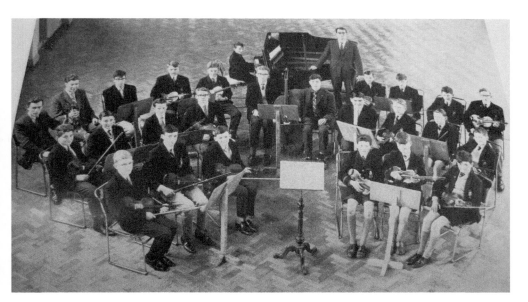

Above Mr L. Forristal with the college orchestra in 1961. (Courtesy of Gort Muire Carmelite Library)

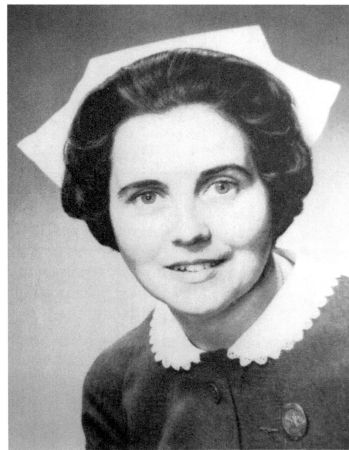

Right Miss E. Cronin, the popular matron, in 1963. (Courtesy of Gort Muire Carmelite Library)

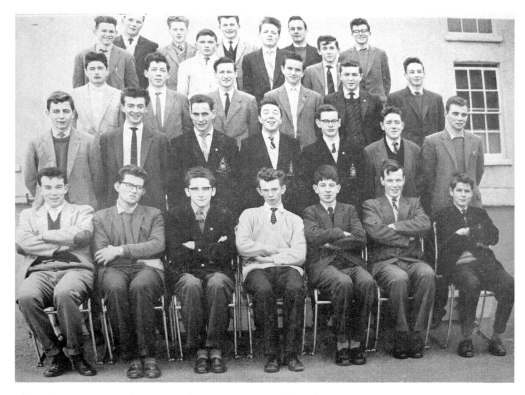

The 5th year in 1961. (Courtesy of Gort Muire Carmelite Library)

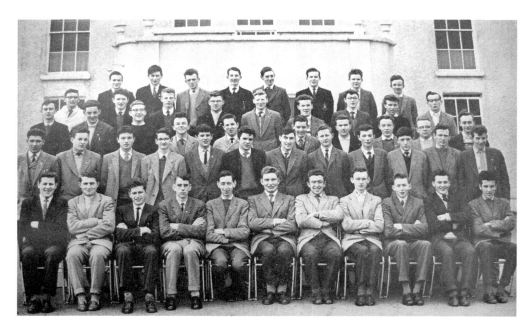

The 6th year in 1961. (Courtesy of Gort Muire Carmelite Library)

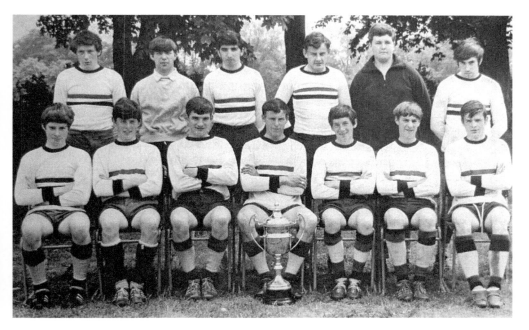

Senior soccer team, winners of Leinster Trophy, 1969. From left to right, front row: G. Morrissey, J. Cronin, C. Sparks, B. Stewart, R. McEnerney, T. Jones, D. Stewart. Back row: P. Meade, B. Lynham, A. Isaac, D. Lamont, D. Fennin, N. Germaine. (Courtesy of Gort Muire Carmelite Library)

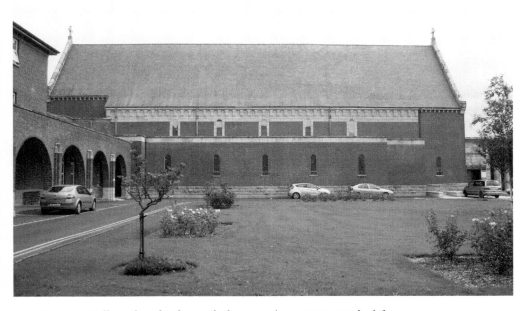

Terenure College chapel today, with the priests' monastery on the left.

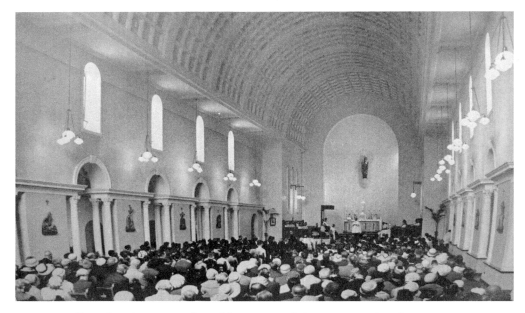

Terenure College chapel is open to the public – notice all the women in this photo are wearing hats and bonnets in this 1960s photo. (Courtesy of Gort Muire Carmelite Library)

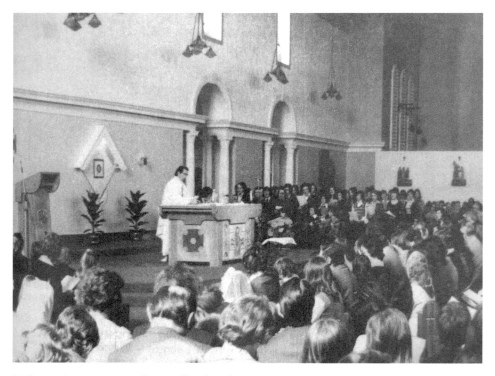

'Folk Mass' in Terenure College public chapel, 1974. (Courtesy of Gort Muire Carmelite Library)

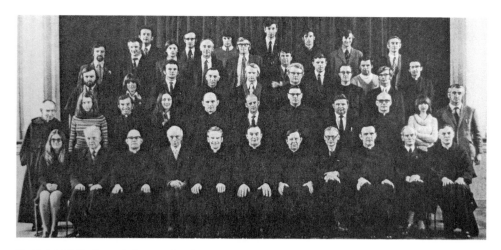

Staff, 1972/3. From left to right, front row: Mrs M. Murray, P. O'Brien, Fr P.C. Keenan, J.F. Griffin, Fr A.W. Weakliam, Fr P.S. Grace, Fr J.A. Madden, C.B. Collins, Fr K.A. Clarke, M. O'Connell, Fr J. McCouaig. Second row: Fr G. Traynor, Miss T. Kirke, Fr L. Fennell, Miss M. Fitzgerald, Fr J.J. O'Hea, T. Byrne, Fr T. Brennan, V. Morris, Fr J. B. Kinahan, Miss C. Power, K. O'Brien. Third row: D. Hussey, Miss D. Moore, D. Whitty, Fr T.D. Doran, J McClean, Fr P.P. Graham, Fr J. O'Nolan, S. O'Connor. Fourth row: M. O'Bradaigh, P. Cahill, J. McDonnell, D. Moriarity, S. McCool, K. Doherty, J. Hunt, L. Williamson, Fr D. Kelly. Back row: J. O'Callaghan, A. Donagher, K. MacMahon, D. Carroll, Fr B. O'Reilly, A. Kearney, P. O'Brien. (Courtesy of Gort Muire Carmelite Library)

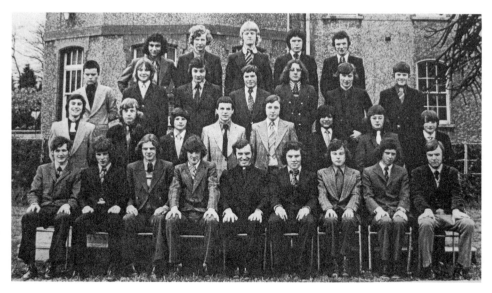

The last boarders, 1972/3. From left to right, front row: G. Gibson, A. Brennan, A. Lonergan, J. Smith, Fr Fennell, N. Fitzgerald, J. Brankin, T. Gaffney, D. Hickey. Second row: S. Kenny, P. McDowell, E. Williams, E. Kenny, M. Hegarty, K. Monteiro, B. Walker, N. Williams. Third row: M. Brennan, T. McClean, G. Greene, L. McCabe, P. Greene, L. Brennan, P. Macken. Back row: E. Anthony, T. Kelly, J. Hatton, J. Cusack, T. Greene. (Courtesy of Gort Muire Carmelite Library)

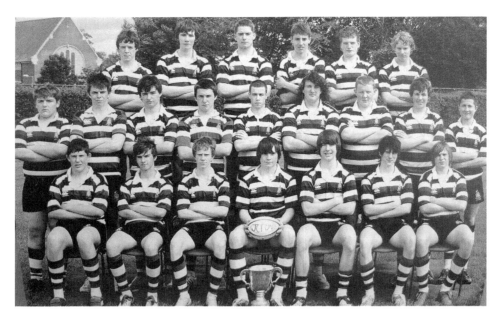

Junior Cup Winners, 2009. From left to right, front row: D. Hynes, G. Clarkin, J. Wright, N. Lalor, M. Hayes, A. Trimble, S. Purcell. Middle row: S. Borza, F. Bagnall, R. Church, D. McCormack, P. Smith, A. Somerville, C. Owens, H. Brewer, S. O'Neill. Back row: S. Keogh, S. Croke, R. Somerville, J. Kirwan, A. Donoghue, C. Jones. (Courtesy of Gort Muire Carmelite Library)

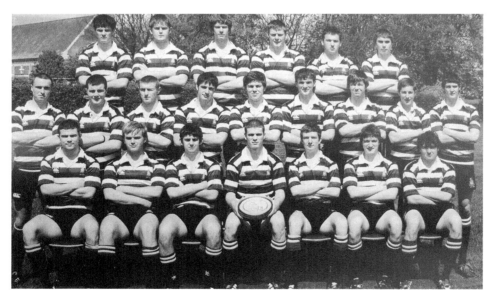

The 2009 Senior Cup finalists. From left to right, front row: R. Williamson, A. Clarkin, J. Thornton, R. Duke, H. Moore, C. Shanahan, S, Reid. Middle row: S. Lowe, B. Mooney, N. Casey, S. Doherty, D. O'Dowd, C. Kelly, A. Byrne, K. O'Neill, M. Hyland. Back row: E. Joyce, R. Burdock, G. O'Doherty, C. Deans, P. McCormack, J. O'Donoghue. (Courtesy of Gort Muire Carmelite Library)

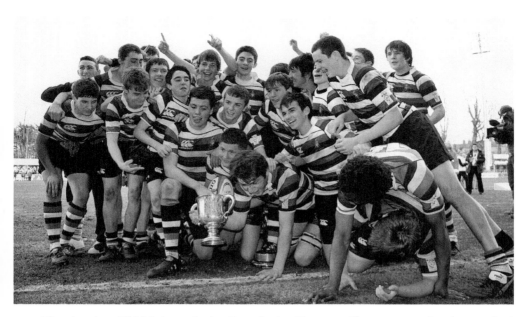

The victorious 2010 Leinster Junior Cup winning Terenure side, moments after they received the trophy.

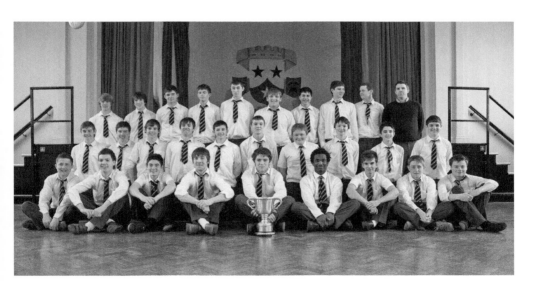

The Terenure Junior Cup side, Leinster Champions 2010. From left to right, front row: Stephen O'Neill , Harrison Brewer, Alex Hyland, Matthew Hayes, Robert Somerville (capt.), Hilary Nwankwo, Gary Clarkin, Kevin Lynam, Niel O'Connor. Middle row: Patrick Thornton, Tom O'Brien, Stephen Caffrey, Robert Carroll, Jake Swaine, Jordan Lynch, Conor Dignam, Jimmy McCormack, Robert Murphy, Tom Walsh. Back row: Stuart Bolger, Kevin Colgan, Ronan Church, Eoghan Haddock, Mike Murphy, Silvio Borza, Evan Soave, Jody Carroll, Niall O'Sullivan, Dermot Blaney (coach).

Terenure College Rugby Football Club pavilion.

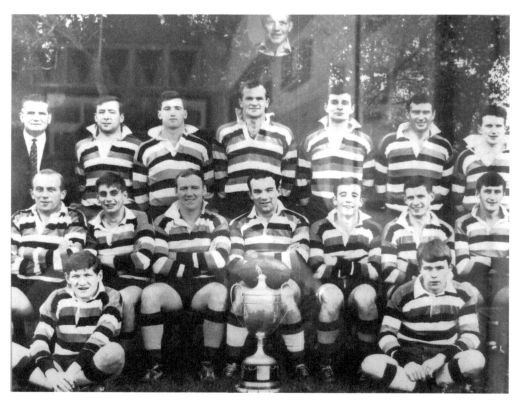

Terenure Rugby Football Club, winners of Leinster Senior Cup, 1965/6. From left to right, front row: B. Sherry, F. Glennon. Inset: M. Hipwell. Middle row: J. Doyle, E. Thornton, P. Gaffney, E. Coleman, B. Gorevan, G. Tormey, R. Flannery. Back row: G. O'Connor, P. Browne, P. Mayne, A. Smith, D. Coleman, P. Kelly, G. Martin. (Courtesy of Terenure Rugby Football Club)

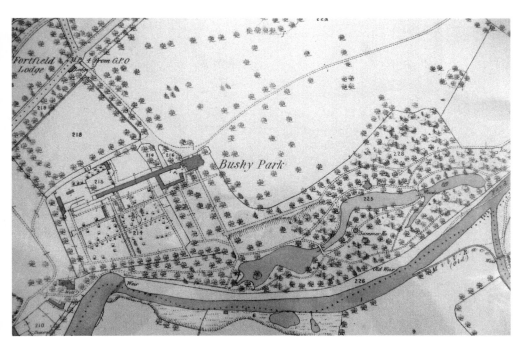

1860s Ordnance Survey map of Bushy Park demesne, with the River Dodder along the lower edge. Note the '4-miles from GPO' marker at top left. The lakes are now part of 'Shaws Wood'. (Courtesy of the South Dublin County Council Library & Archive)

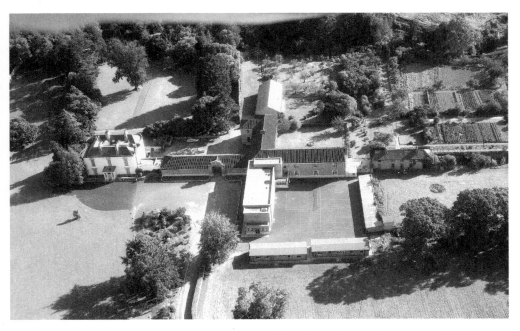

A 1969 aerial view of Our Lady's School, with the old Bushy Park House/convent on the left. (Courtesy of the National Library of Ireland)

The old Bushy Park House/convent (white building on the left) currently lies vacant.

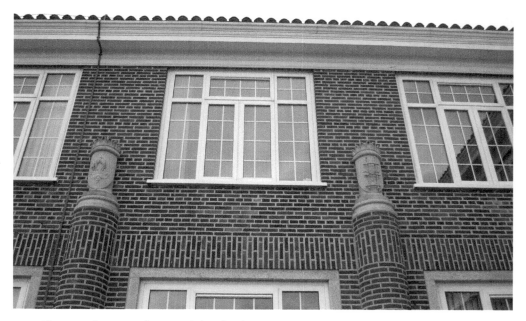

The rear elevation of Our Lady's School incorporates a unique display of seventeen different Marian symbols from the Bible, each a work of art.

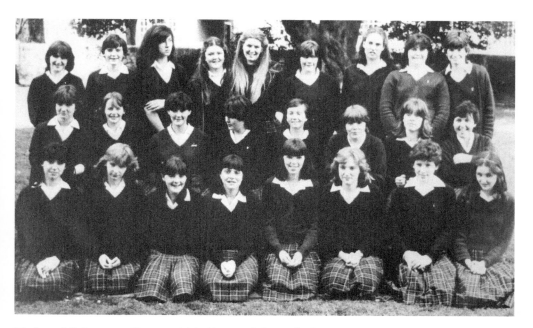

L3 class of St Laurence House in 1982/3. From left to right front row: Barbara Nolan, Zara Lee, Andrea Flynn, Sharon Flynn, Barbara Behan, Norin Halligan, Fiona Corr, Donna Lakes. Middle row: Elizabeth Murphy, Noeleen Lynch, Marianna Tiernan, Tina Selby, Orla Mooney, Tracy Piggott, Helen Halpin, Denise Cousins. Back row: Aisling Tobin, Elizabeth Sheehan, Fionnuala Fallon, Ciara Donnelly, Ciara Cavanagh, Anne Marie Hughes, Jennifer O'Neill, Aisling O'Brien, Aine Gallagher. (Courtesy of the National Library of Ireland and Our Lady's School)

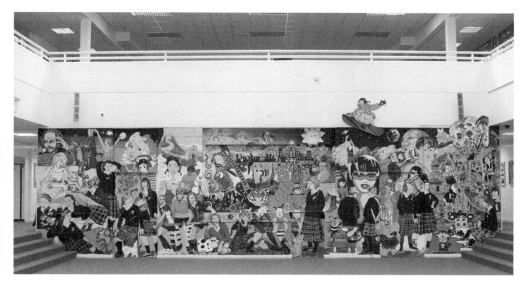

The General Purpose Area in Our Lady's has a lovely wall mural, painted by the fourth-year students in 2010/11.

Some of Our Lady's School pupils.
(Courtesy of the National Library of
Ireland and Our Lady's School)

Our Lady's School junior staff. May Spinks
was the popular founder of the Harolds Cross
Musical Society. (Courtesy of the National
Library of Ireland and Our Lady's School)

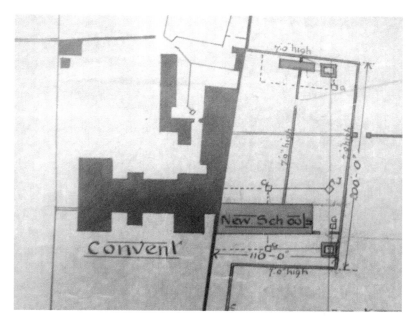

The 1889 original plan of the Presentation National School. Boys and girls toilets were at the rear of the playground. (Courtesy of the National Archives of Ireland)

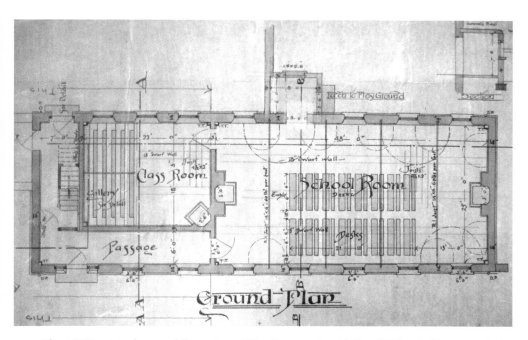

The 1889 original ground floor plan of the Presentation National School. (Courtesy of the National Archives of Ireland)

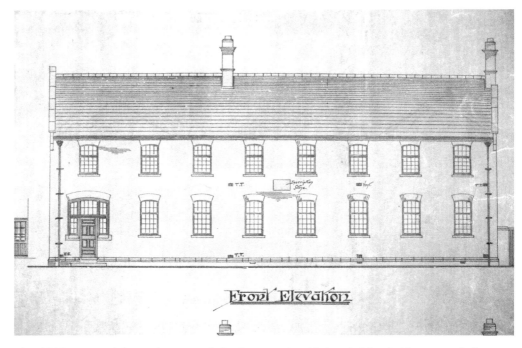

The 1889 proposed front elevation of the Presentation National School. (Courtesy of the National Archives of Ireland)

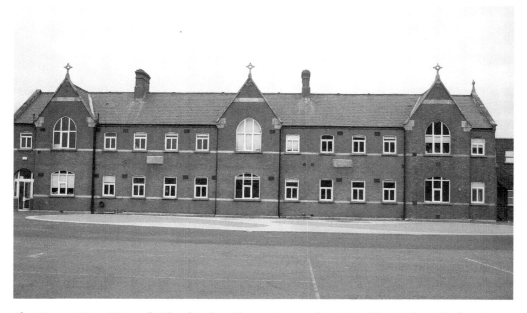

The Presentation National School today. The section to the right side of the right-hand chimney was added in 1903.

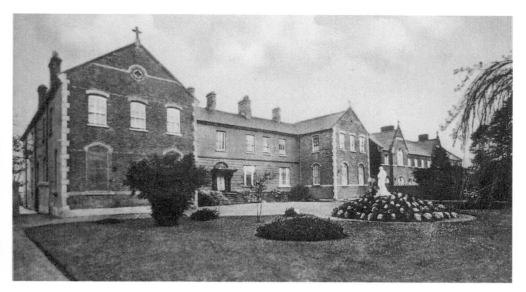

Another view from around 1900. The convent takes up most of the photo, and the 1889 National School is on the far right – note that the latter has only two gables, since it has not yet been extended. The nuns' chapel was on the lower left. (Courtesy of the Presentation Primary School)

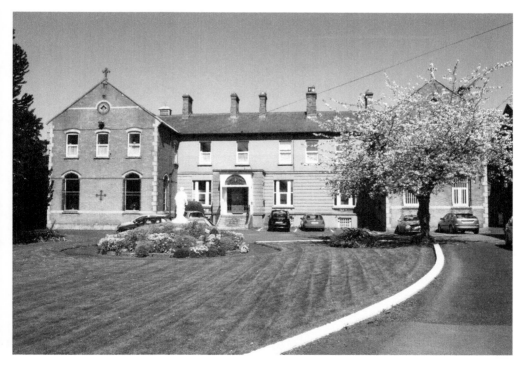

The Presentation Convent in 2006, just before demolition. The chapel was on the ground floor of the left-hand wing. (Courtesy of the Presentation Primary School)

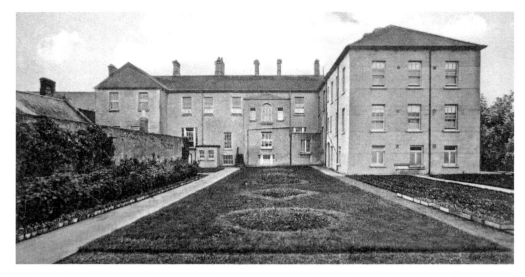

The rear of the convent, *c.* 1900. The original single-storey National School roof is visible on the left. (Courtesy of the Presentation Primary School)

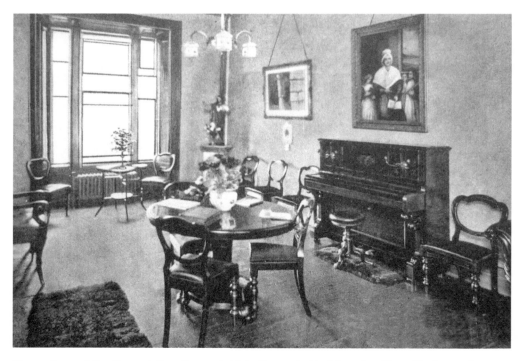

The parlour of the Presentation Convent. Note the portrait of founder, Nano Nagle, on the right-hand wall. (Courtesy of the Presentation Primary School)

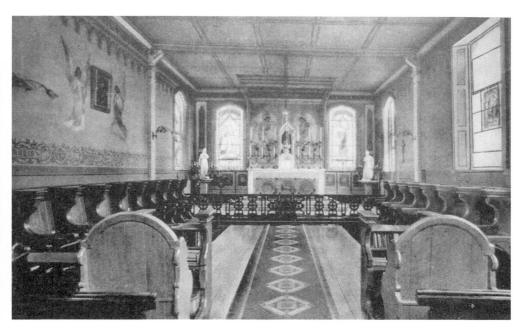

The convent chapel, *c.* 1900. (Courtesy of the Presentation Primary School)

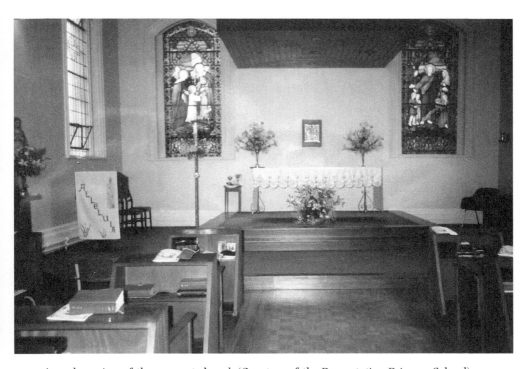

A modern view of the convent chapel. (Courtesy of the Presentation Primary School)

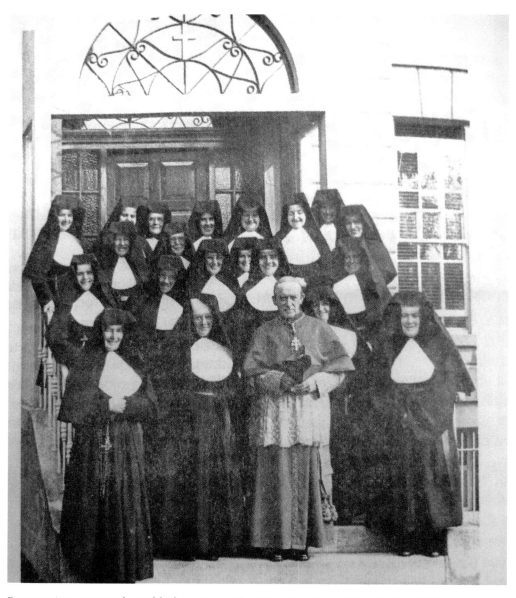

Presentation nuns with Archbishop McQuaid, 1966. (Courtesy of the National Library of Ireland)

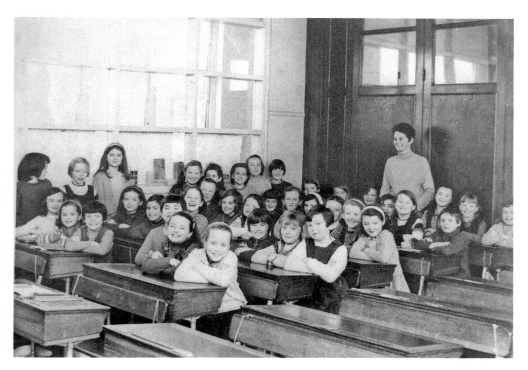

Presentation classroom in 1969. (Courtesy of the Presentation Primary School)

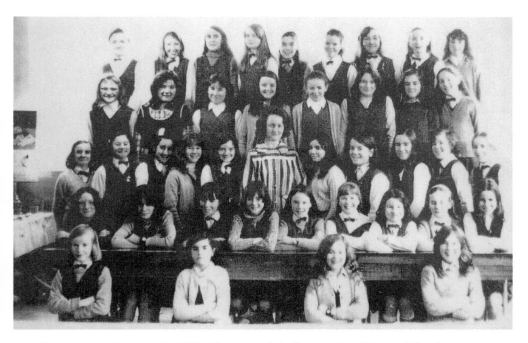

Presentation classroom in 1971. (Courtesy of the Presentation Primary School)

Sr Carmel (Mother Superior) on prize-giving day at Presentation National School, 1973. (Courtesy of the Presentation Primary School)

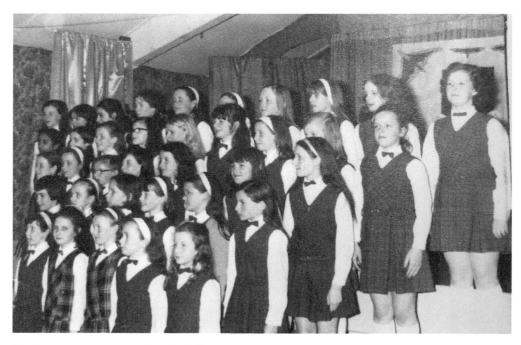

The Presentation National School choir in 1971. (Courtesy of the Presentation Primary School)

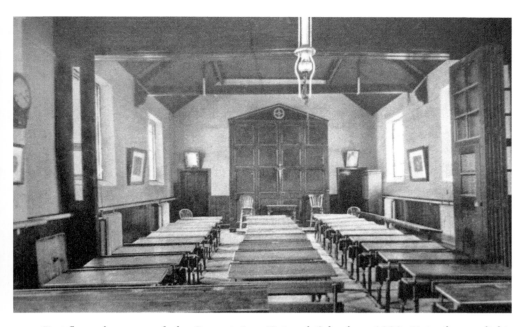

First-floor classroom of the Presentation National School, *c.* 1900. Note the gas-light. (Courtesy of the Presentation Primary School)

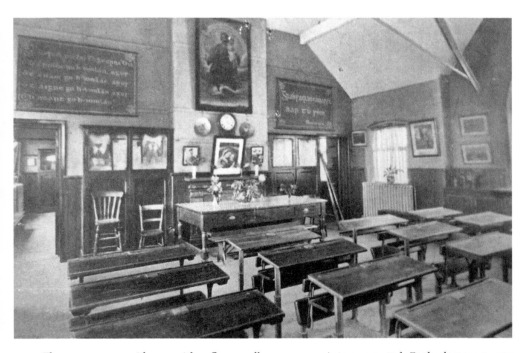

There was no corridor on either floor – all rooms were interconnected. Each classroom was named after a favourite saint. (Courtesy of the Presentation Primary School)

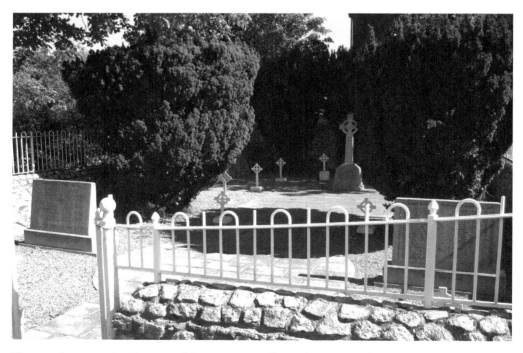

from 1st June to 29 Aug	(Same period).
411	254.4

Inspected on 29 day of August from 1.25 o'clock to 2.45 o'clock.

I.—PRESENT TEACHING STAFF.						II.—NUMBER PRESENT, &C.					
Position in School.	NAME IN FULL.	Age.	Date of entry on duty here.	Class.	IF TRAINED, STATE		CLASS.	Boys	Girls	Total.	No. of the foregoing who were present at the last Results Examination
					Year.	COLLEGE.					
Principal,	Pres Nuns						Infants, -	60	46	106	
Lay Assistant,	Mrs M. A Ennis		1.78	2¹			Class I.	12	26	38	
Do.	" A Sinnott		8.04	1²	1902-1904	Carysfort	" II.		28	28	
Do.	" A Mooney		8.95	2¹	1890.2	Marlboro	" III.		31	31	
W. Mistress	" T Ennis		8.00	3²			" IV.	18	1	19	not 15
Monitor,	" French		4.94	Monitor,			" V¹.	19		19	
Monitor	Maggie Forde		7.1900	Do.			" V².				
Do.	Maggie Hanlon		7.1902	Do.			" VI¹.	12		20	not 15
	Annie Forde		7.1904				" VI².				
							TOTAL, -	72	180	9	Total 261

III. If the principal teacher, and at present employed in this School, has been Trained in a recognized Training College within the past 5 years, give particulars as to :—

A 1904 report on the Presentation National School. (Courtesy of the National Archives of Ireland)

The nuns' graveyard at the rear of Presentation College. The 1871 High Cross provides a link with the nuns' former school in Richmond Road, Fairview.

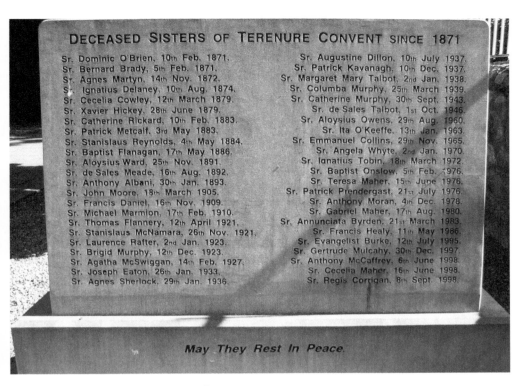

DECEASED SISTERS OF TERENURE CONVENT SINCE 1871

Sr. Dominic O'Brien, 10th Feb. 1871.
Sr. Bernard Brady, 5th Feb. 1871.
Sr. Agnes Martyn, 14th Nov. 1872.
Sr. Ignatius Delaney, 10th Aug. 1874.
Sr. Cecelia Cowley, 12th March 1879.
Sr. Xavier Hickey, 28th June 1879.
Sr. Catherine Rickard, 10th Feb. 1883.
Sr. Patrick Metcalf, 3rd May 1883.
Sr. Stanislaus Reynolds, 4th May 1884.
Sr. Baptist Flanagan, 17th May 1886.
Sr. Aloysius Ward, 25th Nov. 1891.
Sr. de Sales Meade, 16th Aug. 1892.
Sr. Anthony Albani, 30th Jan. 1893.
Sr. John Moore, 18th March 1905.
Sr. Francis Daniel, 16th Nov. 1909.
Sr. Michael Marmion, 17th Feb. 1910.
Sr. Thomas Flannery, 12th April 1921.
Sr. Stanislaus McNamara, 26th Nov. 1921.
Sr. Laurence Rafter, 2nd Jan. 1923.
Sr. Brigid Murphy, 12th Dec. 1923.
Sr. Agatha McSwiggan, 14th Feb. 1927.
Sr. Joseph Eaton, 26th Jan. 1933.
Sr. Agnes Sherlock, 29th Jan. 1936.

Sr. Augustine Dillon, 10th July 1937.
Sr. Patrick Kavanagh, 10th Dec. 1937.
Sr. Margaret Mary Talbot, 2nd Jan. 1938.
Sr. Columba Murphy, 25th March 1939.
Sr. Catherine Murphy, 30th Sept. 1943.
Sr. de Sales Talbot, 1st Oct. 1946.
Sr. Aloysius Owens, 29th Aug. 1960.
Sr. Ita O'Keeffe, 13th Jan. 1963.
Sr. Emmanuel Collins, 29th Nov. 1965.
Sr. Angela Whyte, 2nd Jan. 1970.
Sr. Ignatius Tobin, 18th March 1972
Sr. Baptist Onslow, 5th Feb. 1976.
Sr. Teresa Maher, 15th June 1976.
Sr. Patrick Prendergast, 21st July 1976.
Sr. Anthony Moran, 4th Dec. 1978.
Sr. Gabriel Maher, 17th Aug. 1980.
Sr. Annunciata Byrden, 21st March 1983.
Sr. Francis Healy, 11th May 1986.
Sr. Evangelist Burke, 12th July 1995.
Sr. Gertrude Mulcahy, 30th Dec. 1997.
Sr. Anthony McCaffrey, 6th June 1998.
Sr. Cecelia Maher, 16th June 1998.
Sr. Regis Corrigan, 8th Sept. 1998.

May They Rest In Peace.

Headstone in the nuns' graveyard.

The Presentation Secondary School is now run by the VEC, as Presentation College.

Presentation College Staff, 1994. From left to right, front row: Austin Kearney, Anne Clarke, Caitriona McDonnell, Paula Gregory, Susan Horton, Kay O'Dwyer, Margaret McDermott, Elizabeth Collins, Lorraine Jones, Nuala Cranley. Second row: Meabh Coogan, Declan Murphy, Gerry Coogan, Deirdre MacEntee, Clodagh McMoreland. Third row: Sally Bourke, Conor Norton, Una McCarthy, Deirdre Smyth, Damienne Letmon, Susan McEntee, Adrienne Kinsella, Sr Una Trant, John Loughman, Margaret Carroll, Valerie O'Donnell. Back: Audrey Murphy, Sean Pidgeon, Margaret O'Shea, Carmel Maguire, Patricia Langan, Rosemary McGinley, Mary McIver, Elizabeth Silke, Marie de Paor. Inset: Moira Terry-Smyth, Paddy King, Caren McDonnell, Ailish O'Brien, Siobhan ni Chleirigh. Sr Catherine Quane is absent from the photo. (Courtesy of the Presentation College)

Presentation College Class 6G, 1994. From left to right, front row: Mary Murphy, Belin Maginn, Jane Connolly, Siobhan Gould, Sharon Deane, Sabrina Lloyd. Middle row: Ms O'Donnell (class tutor), Treasa McNicholas, Sharon Norton, Cliona Ryan, Fiona McCarthy, Deborah Barrett, Kirstine Keyes. Back row: Susan Knott, Aoife Cleary, Anita Beswick, Tara Moore, Collette Rafferty. Eve Bridges, Ann Marie Hyland, and Michele O'Brien are missing from the photo. This is only a random sample of the four streams in that year – all equally wonderful. (Courtesy of the Presentation College)

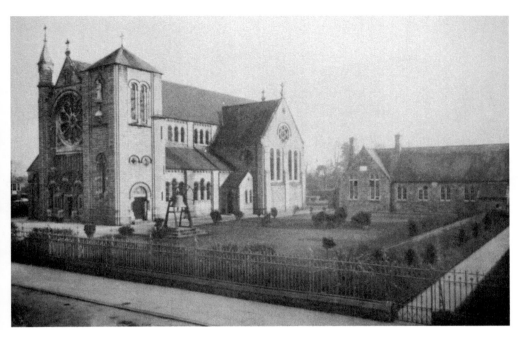

St Joseph's church in the early twentieth century. The boys' National School is on the right, including the entrance porch on the extreme right. The gabled section on the left of the school was originally St Joseph's chapel-of-ease. (Courtesy of the National Library of Ireland)

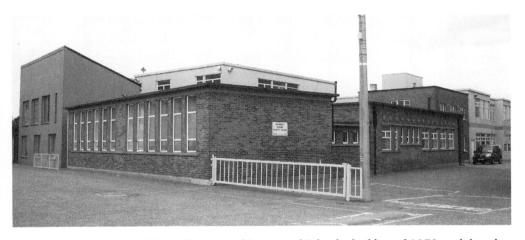

The single-storey building is the St Joseph's National School rebuilding of 1972, and the other sections are mostly recent prefabs.

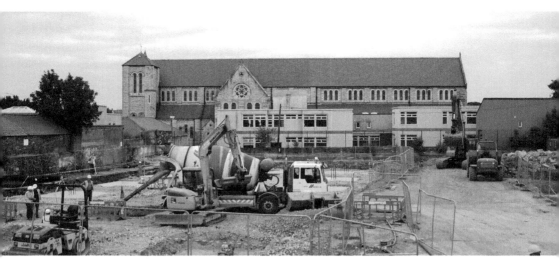

St Joseph's church and National School as seen from the new Lidl building site.

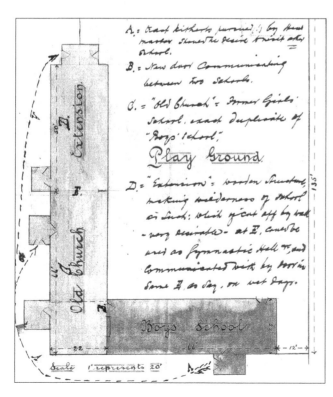

An early twentieth-century plan of St Joseph's National School and former chapel-of-ease. (Courtesy of the Diocesan Archives)

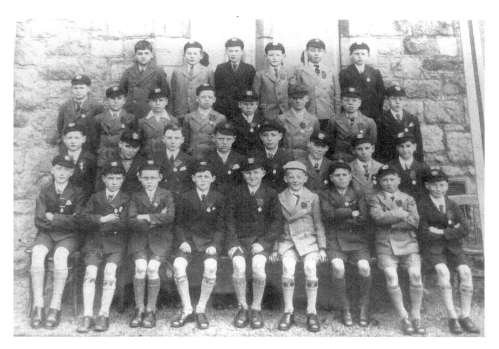

A 1936 class photo taken outside St Joseph's National School. (Courtesy of St Joseph's National School)

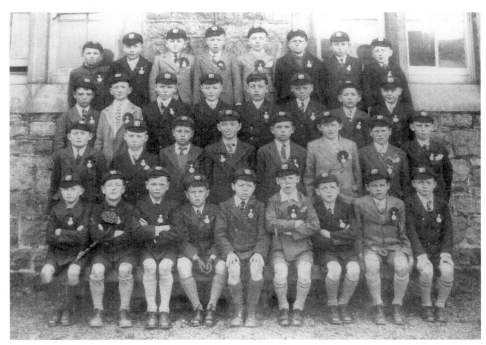

A 1942 class photo taken outside St Joseph's National School. (Courtesy of St Joseph's National School)

St Joseph's in 1975. Prizes awarded at the Dublin Primary Schools Sports at Santry. From left to right, front row: F. Mahon, C. Anderson, K. Dunleavey, R. Roberts. Middle row: A. Reville, R. Ellis, S. Wall, K. Hoyne, P. O'Toole. Back row: D. Kenny, C. Anderson, J. Keaty, C. Sullivan, P. Daly, M. Murphy. (Courtesy of the National Library of Ireland)

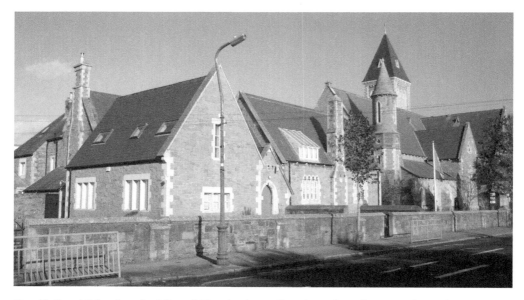

Zion National School on the left, and Zion Anglican Church on the right, on Bushy Park Road. Limestone is used in both buildings, which were designed by Joseph Welland. The left wing of the school was added in 1998, and a first floor inserted into the original single-storey school, bringing the pupils closer to the 'scissor' roof trusses. The former schoolmaster's house is behind the school building.

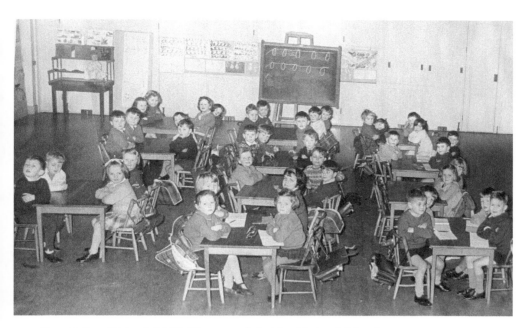

Zion National School, 1965. (Courtesy of the Zion National School) ·

2

RELIGION

ST JOSEPH'S CATHOLIC CHURCH

Terenure was part of Rathfarnham parish until 1894, after which a separate parish of Terenure and Crumlin was created. Crumlin became a separate parish in 1941.

By deed dated 17 December 1862, James Tobin sold a plot of land in Terenure, being part of 'The Broads', comprising 1 acre, 2 roods and 19 perches, including a lodge called Pleasant View, to the Most Revd Dr Cullen, Revd William Meagher, and Revd Tiernan Terence Dolan.

The granite chapel-of-ease was built on this plot of land in 1866, attached to the east side of a new boys' National School, and measured 116 feet by 22 feet. Originally this space was going to be the girls' National School, until it was realised that the Presentation Sisters had opened a nearby girls' National School, called St Joseph's. Therefore, the 66 feet long girls' school was extended by 50 feet, using a timber structure, to make it suitable as a chapel.

A much bigger church opened in 1904 (the foundation stone was laid in 1898) at the front of the school site. It was designed by W.P. Byrne and built by Michael Meade & Sons, Great Brunswick Street (now called Pearse Street). The former chapel was assigned to the boys National School.

In 1956, the church was extended southwards, increasing its capacity from 900 to 2,000, so that the priest faced into the new section and had his back to the original section. Of interest is the huge timber cross over the altar, with Jesus on both sides.

Various repairs and re-slating were carried out in the 1990s, and the organ under the rose window replaced with one which was originally in a Belfast Presbyterian church.

The architect intended the original church to have a bell tower, but alas, the bell still sits on the ground in the forecourt.

Inside, the stained-glass windows of Harry Clarke, in the three-light window at the rear, are noteworthy. They were erected in 1920 in memory of Major Gorman, Edward and Jeannie de Verdon Corcoran, and depict the crucifixion.

Originally Terenure parish took in the Templeogue area, but the Church of St Pius X was completed in 1960 and a new parish formed in 1964. Father Joseph

Union was the parish priest of Terenure at the time, and his fundraising efforts included a 'Cowboys and Indians' garden fête in 1958, in the former grounds of St Mary's Rugby Club.

ZION ANGLICAN CHURCH

This church is at the east end of Bushy Park Road, and has nothing to do with the nearby Jewish Stratford College on Zion Road.

Built in 1861, to a design by Joseph Welland, it was originally a Trustee church; that is, independently funded and run. There are some nice stained-glass windows, including a two-light one by A.E. Child, on the north of the nave.

Opposite the west end of Bushy Park Road stands both the Parochial Hall and Rectory for Rathfarnham Anglican Church. This attractive Stringer-built hall, which opened in 1923, was called the War Memorial Hall, and the usual list of names is displayed on a timber plaque. In 1924, the Shaw family presented a timber Celtic cross in memory of all denominations (Catholic and Protestant) who died in the First World War. The Rathfarnham Anglican National School was based in the hall from 1962-67.

METHODIST CHURCH

This church at the corner of Brighton Road was built in 1874, although the transepts date from 1924, being a War Memorial project.

PRESBYTERIAN CHURCH

Christ Church was officially opened in 1862, but greatly extended in 1901. It is a landmark at Rathgar crossroads.

MORMONS, 48 BUSHY PARK ROAD

Properly called the Church of Jesus Christ of Latter-day Saints, founded by Joseph Smith in 1830, with headquarters in Salt Lake City, Utah, America. Their 'Bible' is the Book of Mormon. Baptism usually is undertaken by immersion in a sunken bath, when the person is at least eight years old. The Sunday service includes partaking of bread and wine. Their Terenure church opened in April 1974.

JEWISH SYNAGOGUES

Tucked behind 77 Terenure Road North, in Rathmore Villas, is a small active orthodox synagogue called Machzikei Hadass, having an outward appearance of a warehouse, but very homely inside. This was set up when the small synagogue at 7 St Kevin's Parade (off Lower Clanbrassil Street) closed down in the 1960s. The new synagogue was officially opened in April 1968 by Aaron Steinberg, although, from 1960, No. 77 was used as a Jewish Youth Club, for dances, etc. The synagogue now has about twenty-five members. There is no gallery, but instead, the women sit behind a rear lace-curtained screen. The men wear a white shawl

with black stripes, and can sometimes be seen walking to and from service on a Saturday morning.

Just past Terenure crossroads, at 32a Rathfarnham Road, well secured behind two lots of high gates and tall trees, is the main Orthodox Synagogue for Dublin Jews (there is also a Progressive Synagogue at 7 Leicester Avenue behind Rathgar Church of the Three Patrons). The Terenure synagogue had its origins at 6 Grosvenor Place in 1936, followed in 1940 by 52 Grosvenor Road (now the Rathgar Catholic Parish Centre), and finally moving to Terenure around 1948, initially occupying a Nissen Army Hut until the new premises were completed in 1953 (the old house here was called 'Leoville' and 'Palerno' at different stages). The two foundation stones are dedicated to Samuel Noyek and Simon Fine. This spacious building has a long lean-to roof, covered with corrugated asbestos cement sheeting. The women and children are segregated from the men and occupy the rear gallery/balcony. Following a small fire in 1965, the premises was substantially rebuilt and refurbished in 1967, and the opportunity taken to install large stained-glass windows in the north and south elevations. The north window, depicting Jerusalem, was presented by Noyek Bros. The south window depicts ten religious festivals in vivid colours. The Samuel Taca Hall is beside the synagogue, and likewise the Millennium Mikvah Ritual Baths (used by women on a monthly basis). Prior to 2000, the Mikvah Baths were in Adelaide Road Synagogue, and before that, a portion of Tara Street Public Baths was set aside for the Jews. There are about 2,000 Jews in Ireland now.

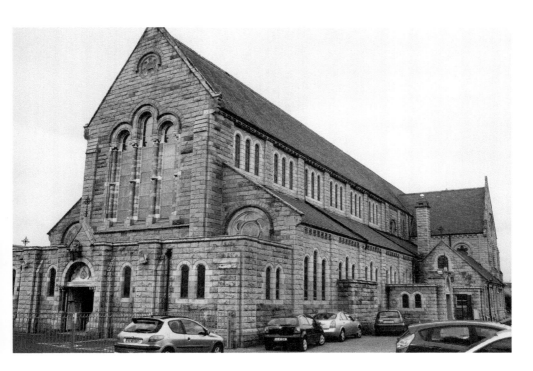

Above Recent view of the extension to the rear of St Joseph's Church.

Right Recent view of the front of St Joseph's church.

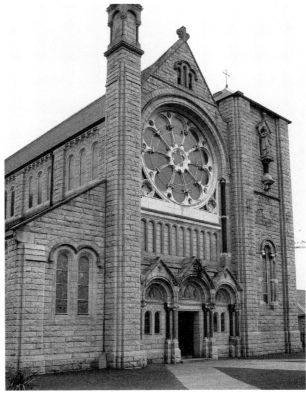

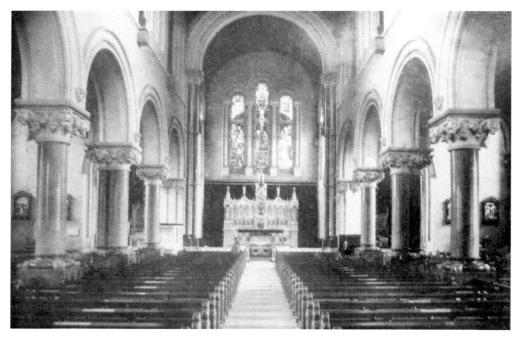

St Joseph's church before it was extended in 1956. The three-light Harry Clarke window was moved to the end of the new extension. (Courtesy of the National Library of Ireland)

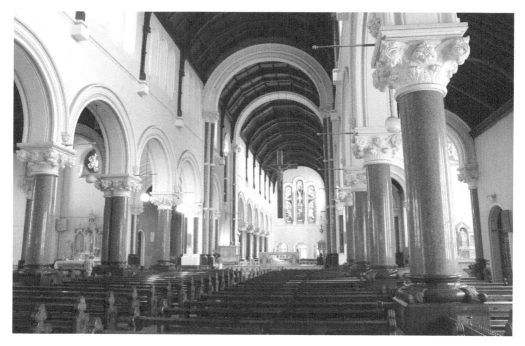

The present St Joseph's, with the altar in the centre of the old and new parts of the church building.

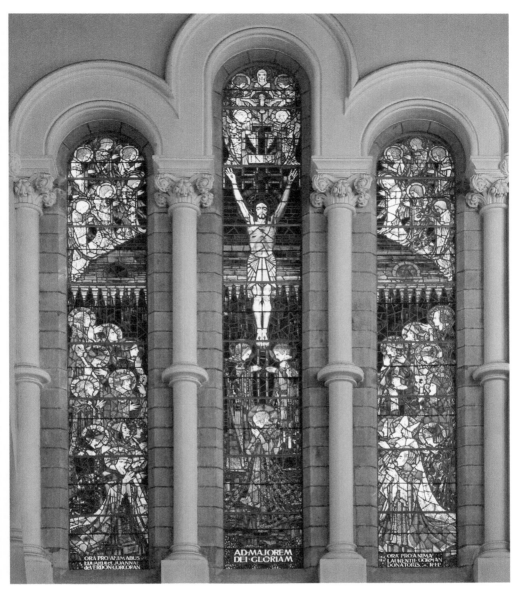

The famous Harry Clarke stained-glass window, depicting the Crucifixion, in St Joseph's church. Note the unusual position of Jesus Christ on the cross, with arms above his head.

List of activities in St Joseph's church, 1963.

Current view of the 1923 War Memorial Hall/Rathfarnham Anglican Parish Hall, with plain rectory behind.

Inside Rathfarnham Parish Hall, with the two war memorials in the corner. The inscription at the base of the timber cross reads: 'Erected by Col. Sir Frederick Shaw and his family in memory of the soldiers of all ranks and denominations from the districts of Terenure and Rathfarnham who gave their lives for their country in the Great War 1914-1919.'

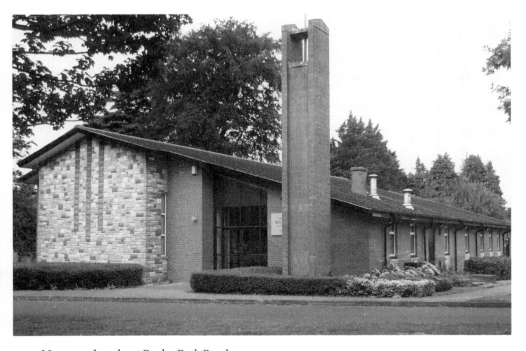

Mormon church on Bushy Park Road.

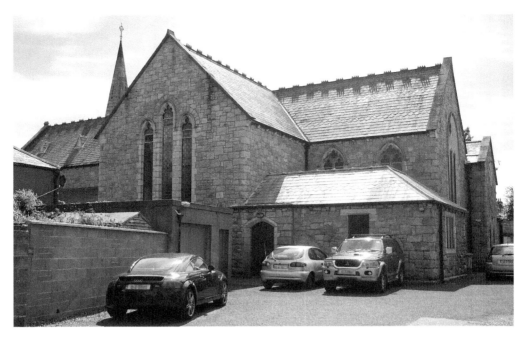

Methodist church on Brighton Square

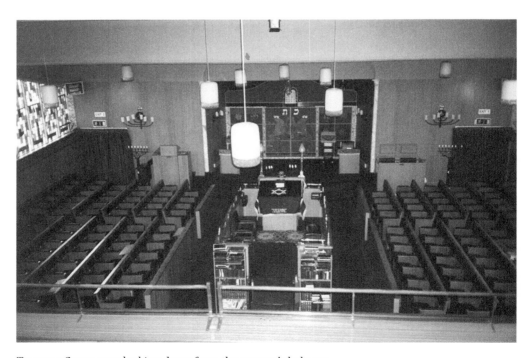

Terenure Synagogue looking down from the women's balcony.

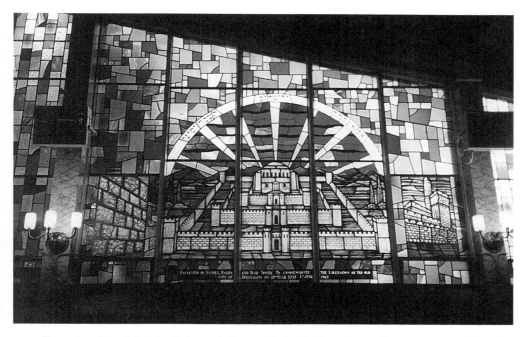

'Jerusalem Temple' stained-glass window, with the Golden Gate in the east town wall, on the north side of Terenure Synagogue.

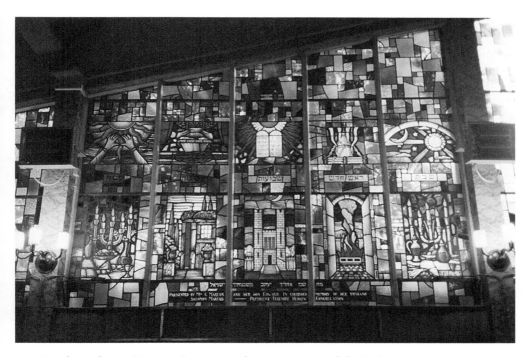

South window in Terenure Synagogue, depicting ten Jewish festivals.

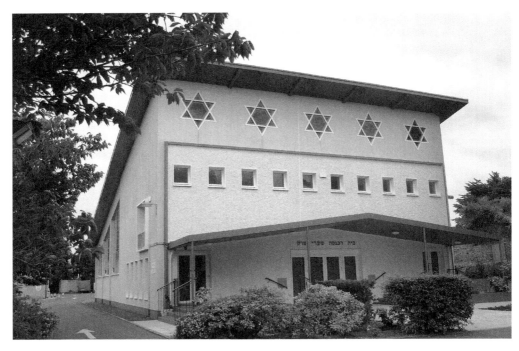

Terenure synagogue, 32a Rathfarnham Road. Note the five 'Star of David' windows at the high level.

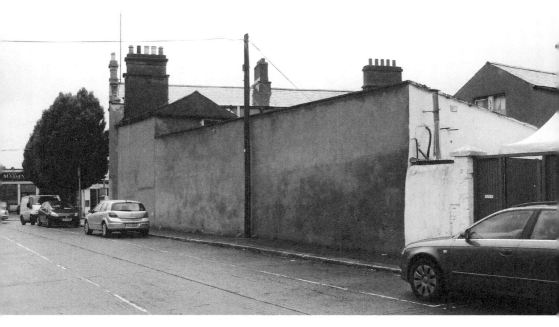

Rathmore Villas synagogue, rear of 77 Terenure Road North. Note Masseys Funeral Directors in the distance on the main road.

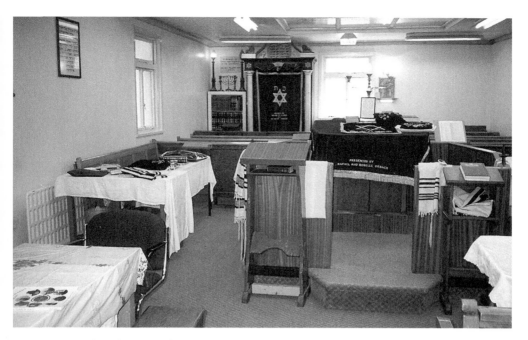

Interior of Rathmore Villas synagogue. The 'bima' is the central platform from where the service is conducted. The Torah scrolls are housed in the rear cupboard marked with the 'Star of David'.

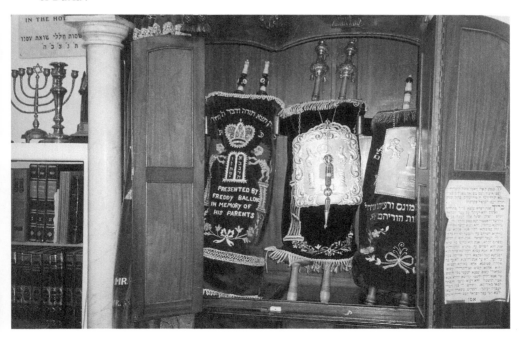

Torah scrolls in Rathmore Villas synagogue. The Torah is written on a calf-skin parchment, which is rolled up on a long rod, and during reading is rolled onto the second rod.

3

RECREATION

BUSHY PARK

The Shaw family is synonymous with Terenure, and author George Bernard Shaw is a distant relative of this family. Thankfully, Dublin Corporation bought Bushy Park House and demesne from the family in 1953 for use as a public park. The Corporation then sold the old house and some land to an order of nuns, who built Our Lady's Secondary School.

Besides the wonderful old trees, including Shaws Wood, the park has an ornamental lake with resident ducks and swans, and runs alongside the River Dodder. Tennis courts, playground and a BMX court are other features. Various local schools use the pitches for football.

RIVER DODDER

From the sixth to the ninth century, there were four main roads radiating from Dublin: Slige Mor to Connaught, Slige Dala to Munster, Slige Midluachra to Ulster, and Slige Chualann to Leinster, the latter passing through present-day Harolds Cross, Terenure, and Rathfarnham.

The ancient highway passed over the River Dodder, and the present single-arch limestone bridge was erected in 1765, replacing earlier efforts. In 1952, the bridge was doubled in width, by erecting a matching reinforced concrete bridge immediately alongside. The old bridge was originally called 'The Big Bridge' but renamed in 1952 as Pearse Bridge. There is a brass plaque alongside the west footpath, showing the heads of Willie and Padraig Pearse in bas-relief, made by Domhnall Ó Murchadha.

The River Dodder is a major Dublin river, and not merely a stream like the River Poddle. The banks are lined with trees of all types, and the environment teems with flora and fauna. The Dodder Anglers Association will vouch for the abundant fish-life. Paths allow walkers and joggers to enjoy parts of the river, although it would be nice if a walk could be provided along the north bank on Lower Dodder Road.

CATHOLIC YOUNG MEN'S SOCIETY

The Catholic Young Men's Society (CYMS) was founded in 1849, and the Terenure branch was founded in 1904 in The Boys Brigade Hall in Richmond Hill, Rathmines. They later moved to St Laurence Hall at 9-11 Harrington Street, near Kelly Corner, remaining here until the mid-1960s. Around 1930, a house and grounds was purchased in Terenure for use as sports grounds, called St Mary's (previously known as Westhampton, and now known as 15 Ashdale Road). The Harrington Street premises was sold to the Gardai in 1963, and a new hall built in Terenure. The original pavillion in Terenure were extended around 1959 to accommodate a bar, and adjoins the present bowling green.

In recent years, the CYMS changed its name to Terenure Sports Club, and caters for rugby (founded 1924/5), soccer (founded in 1904), cricket (founded 1933), bowling (founded 1936), golf (founded 1923), tennis, badminton, and table tennis.

VEC GROUNDS

University College Dublin (UCD) officially came into existence in 1908 (although it had earlier origins), and they built their new college in 1914 in Earlsfort Terrace (now the National Concert Hall). The Sports Club had leased 'Olney' on 14½ acres, on the Templeogue Road, a year earlier, built the timber-framed pavilion, and laid out pitches for soccer, rugby, Gaelic football and hurling, and camogie, in addition to six grass tennis courts. There was also an athletics track, including a 220-yard 'straight'.

These sports grounds were filmed by British Pathé News on various occasions in the 1920s, including College sports days. Girls can be seen sprinting, wearing their full college uniform, including long dresses. The historic 'Tailteann Games' (the Irish equivalent of the Olympic Games) were filmed at the Trials in 1922. Gaelic football games (GAA) are featured on some Pathé News, such as Queens University Belfast versus UCD for the Collingwood Cup in 1926, and UCD versus UCC in the Sigerson Cup in 1926. The official colours of the UCD sports club were 'St Patrick's Blue' and 'Saffron'.

In 1933, UCD had purchased Belfield House, with 44 acres, for use as their new sports grounds, which was the start of a site assembly process for a new campus, which bore fruit in the 1960s.

The City of Dublin VEC started the Sports and Cultural Council in 1935, and leased the vacated University Park in Terenure that same year. In the early days, physical education instruction in the Technical Colleges (the 'techs') was provided by ex-army men. Mr Doogan was the man initially in charge of PE. Over the years many sports and cultural activities were fostered, and pupils looked forward to the annual sports day in Terenure. At one stage there was a running track, besides the football pitches and tennis courts. Rounders (baseball) was popular for many years. In 2010, the club celebrated its diamond jubilee.

St Joseph's Boys National School holds its annual sports day in these grounds.

The VEC is now known as City of Dublin Education and Training Board (CDETB).

BRIGHTON SQUARE

Shaped like a triangle, Brighton Square was laid out in the 1860s and 1870s. The park is not open to the public, having been run by the Residents Trust since 1891. The Tara Tennis Club operates from here.

The quaint south-west lodge inside the park was built in 1908, as a memorial to William Spence, who died in 1907. William Spence & Son Ltd operated from 107 Cork Street, making vats for breweries and machinery for mills. Spence was a Presbyterian, and Freemason, and one of the six lay founders of St Andrew's College in 1894. The boarding school started in 21 St Stephens Green (the site later became part of Stephen Court, home to the recent infamous Anglo Irish Bank), moved to Clyde Road in the 1930s, and finally to Booterstown in 1973. William lived in 68 Brighton Square, beside his in-laws, Henry Lundy (architect) in No. 67. The east wing was added to the park lodge in 2003, giving it a symmetrical appearance.

Although William Spence was a Presbyterian, in 1915 his son, Arthur Spence, presented a bell for the new bell tower attached to the south-west corner of the Anglican church in Harold's Cross, in memory of William and Marion Spence. This half-ton bell was cast for Spence by Taylor of Loughborough in England (No. 194). The top of the tower was removed in 1985, and the bell abandoned for years in the rear yard, although still mounted in its Mathew O'Byrne patent frame. However, the present occupants, the Russian Orthodox Church, ring the bell every Sunday to summon worshipers.

In May 2004, Bloomsday was widely celebrated throughout Dublin in honour of James Joyce, because *Ulysses* was set in Dublin in 1904. James Joyce was born in No. 41 Brighton Square, overlooking the lodge. Crowds gathered in the square to celebrate and read extracts from *Ulysses*.

EVERGREEN CLUB

In one corner of the public car park on Terenure Road North there is a club hall, built in 1972 by the Terenure Old People's Committee of the Red Cross Society, under the chairmanship of Sheelah Flatman. Nowadays the club is independent and voluntary, and cooks a three-course dinner for members on weekdays.

To the south-west of the car park, Dr Margaret Merrick built Merrick Hall (bedsitting rooms) in 1971, and also Auburn House retirement home opposite the Holy Rosary Church in Harolds Cross in 1953.

FLOOD'S BALLCOURT

The beer-garden at the rear of Brady's pub was once a thriving open-air handball court, and parts of the concrete walls are still there. Griffiths Valuation in 1849 records Edward Tighe occupying a house, shop, offices, and ball-court.

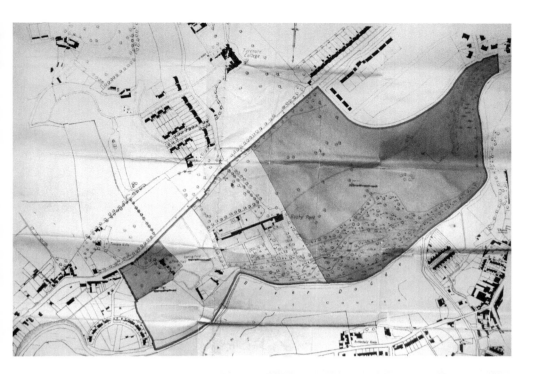

Above 1953 map of Bushy Park Estate which was purchased by Dublin Corporation for use as a public park, although most of the west half was sold for St Mary's School, and Springfield estate. (Courtesy of Dublin City Council)

Right The former outdoor handball alley/court now forms part of the beer garden at the rear of Brady's pub.

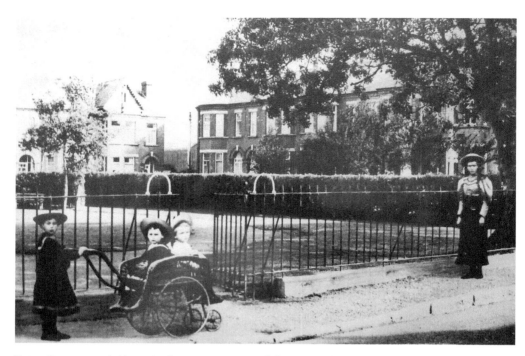

Eaton Square was laid out in the opening years of the twentieth century, and is now a public park with trees and lawns. (Courtesy of the Terenure Inn)

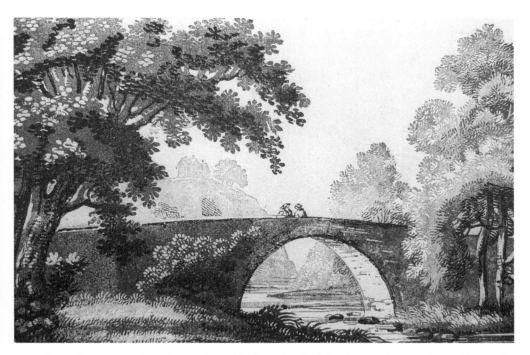

A wood engraving by Thomas Burnside depicting Rathfarnham Bridge in 1796. Notice the house on the hill in the background. (Courtesy of the National Library of Ireland)

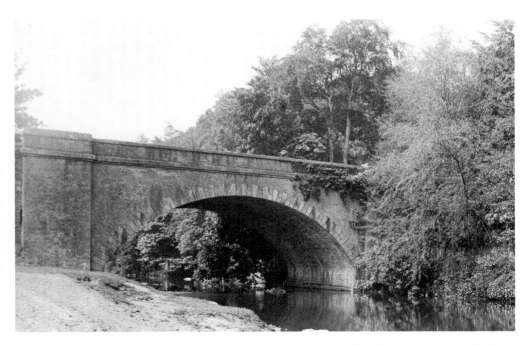

Early twentieth-century view of narrow Rathfarnham Bridge. (Courtesy of the National Library of Ireland)

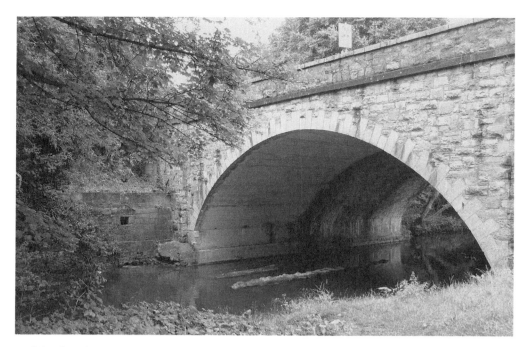

Rathfarnham/Pearse Bridge today, with concrete arch nearest and original limestone arch further east.

Waterfall on the River Dodder, to the east of Pearse Bridge.

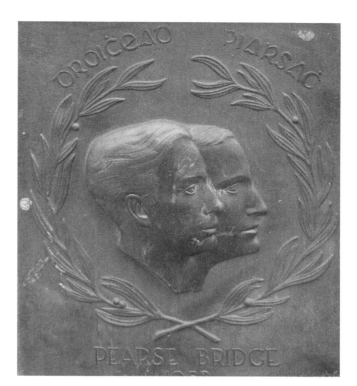

Plaque of Willie and Patrick Pearse on Rathfarnham Bridge.

View from Rathfarnham Bridge west along the Dodder and Bushy Park, when Travellers from all over Ireland came on holiday, July 2001.

Bushy Park now attracts only the bravest cyclists, and most talented street artists.

This part of Bushy Park is not for the faint-hearted!

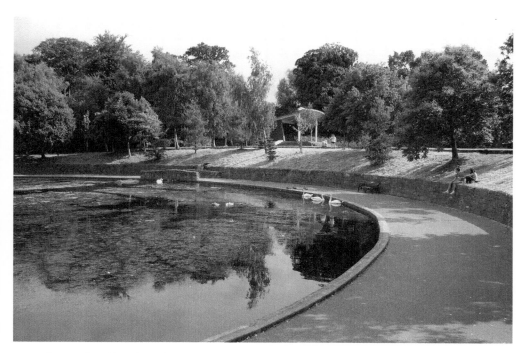

The pond and bandstand in Bushy Park.

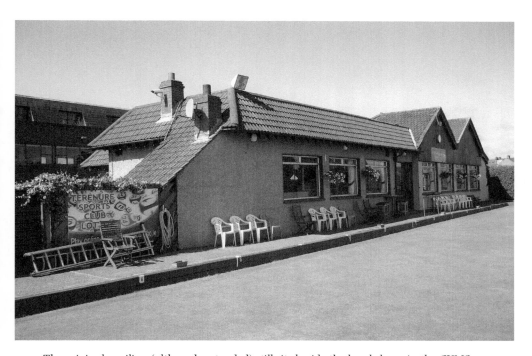

The original pavilion (although extended) still sits beside the bowls lawn in the CYMS.

The main 1960s CYMS hall beside their tennis courts.

Inside the CYMS hall, which caters for indoor sports, and many a lively party.

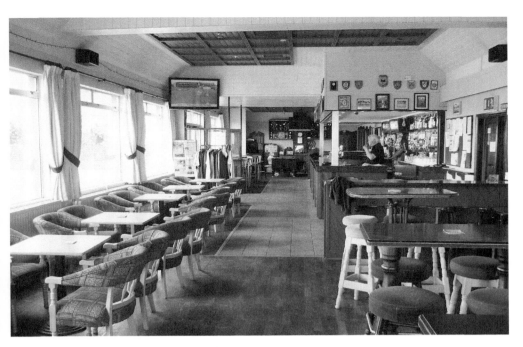

The bar overlooks the CYMS bowls lawn.

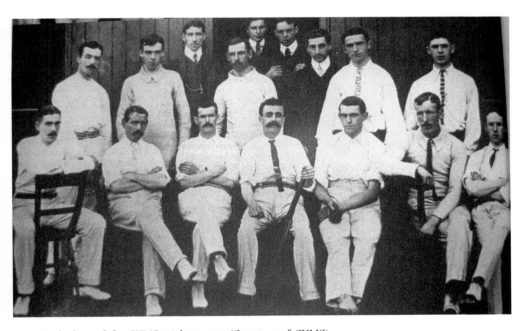

Early days of the CYMS cricket team. (Courtesy of CYMS)

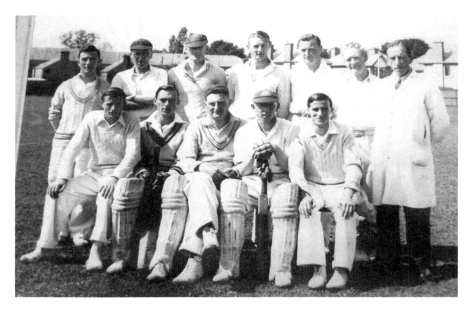

CYMS 1st XI Cricket, 1941. From left to right, front row: J. Morris, C. Brady, J. Mac Menamin (Captain), J. Whitney, P. Morris. Back row: P. Mac Guire, P. Fogarty, J. Smyth, R. Murphy, J. Blake, D. Fogarty, L. Mac Dermott. (Courtesy of CYMS)

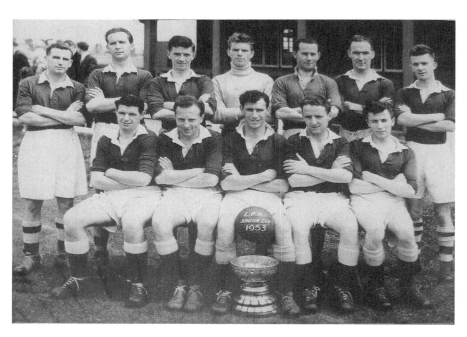

CYMS Football Club, winners of Leinster Junior Cup, 1953/4. From left to right, front row: B. Culligan, G. Sullivan, T. Corcoran (Captain), J. McManus, P. Morrissey. Back row: C. Carroll, J. Collins, P. Merrigan, V. O'Brien, D. Farrell, W. Maloney, N. Henry. (Courtesy of CYMS)

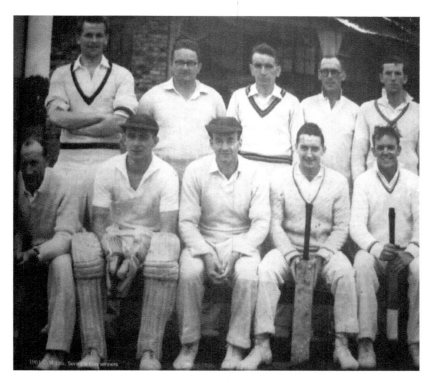

The 1961 CYMS 1st Senior XI. From left to right, front row: F. Morriss, D. McMahon, R. Proctor, W. Butler, D. Donnelly. Back row: A. Smith, N. Herrity, J. McGrath, C. Brady, K. Downey. (Courtesy of CYMS)

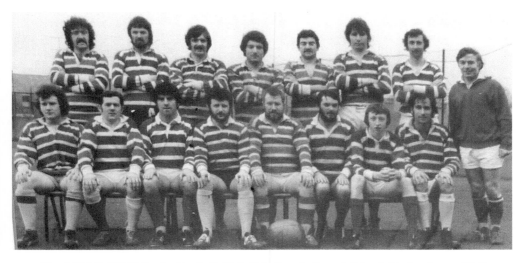

The 1977/8 CYMS Rugby Football Club (4th Team). From left to right, front row: W. Power, B. Carty, K. Connolly, P. Hanratty, T. Keating (Captain), J. Hyland, A. Lavelle, J. Doyne. Back row: P. Coydre, P. Clifford, M. Casey, J. Brett, K. Kenny, J. Lee, C. Connane, D. Moore. (Courtesy of CYMS)

Garda RFC v. CYMS RFC, c. 1976. From left to right: George Trenier (Garda RFC), J. Eagen, M. Croke, D. Garvey, G. Cahill, P. Clifford (all CYMS RFC). (Courtesy of CYMS)

CYMS Table Tennis 1969/70. From left to right: L. Lavary, L. Barry, M. O'Carroll. (Courtesy of CYMS)

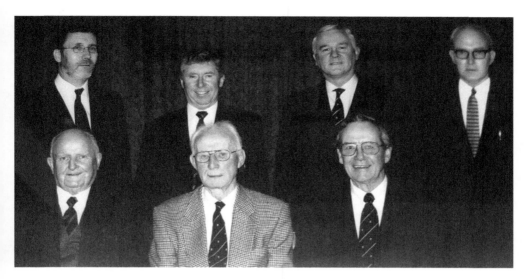

CYMS Presidents from 1955-2001. From left to right, front row: P. Twohig, F. McCarthy, W. P. Fogarty. Back row: P. Hamill, B. Vaughan, B. Butler, W. J. Moloney. (Courtesy of CYMS)

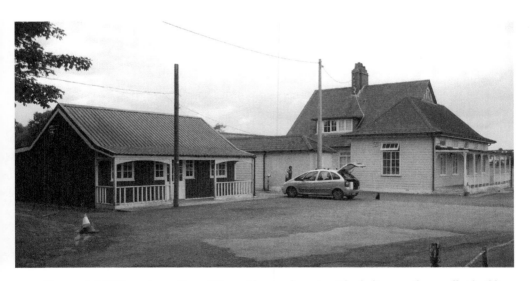

The quaint VEC sports pavilion still provides good service. The ladies use the smaller building on the left.

Inside the front part of the VEC sports pavilion.

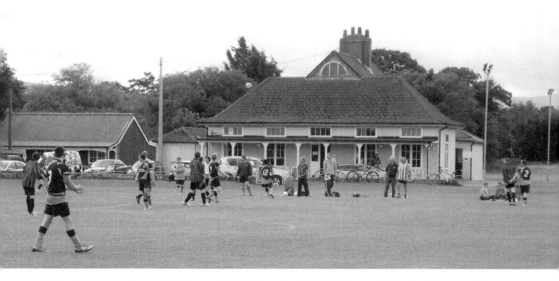

This photo was taken on 10 August 2013, showing the VEC (A team) playing Terenure (B team from Terenure Sports Club/CYMS) in a soccer match. Terenure (Premier team) won the League, Shield, and Cup in 2012/13. Note the quaint timber-framed clubhouse in the background, dating from around 1920.

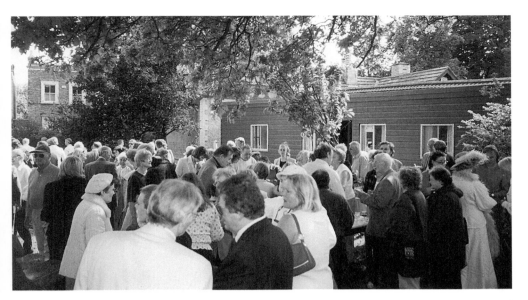

John Stanislaus Joyce, originally from Cork, met Mary Jane (May) Murray in the choir of the Church of the Three Patrons, Rathgar. Although May's parents had an involvement in the Eagle House pub in Terenure in earlier years, at that time May was living in 7 Upper Clanbrassil Street, and John Joyce was living in 15 Upper Clanbrassil Street. They married in 1880 in Our Lady of Refuge Church, Rathmines, and settled in 47 Northumberland Avenue, Dun Laoghaire. They moved to 41 Brighton Square West, where James Joyce was born on 2 February 1882, and he was baptised in St Joseph's chapel-of-ease. In 1884, the Joyce family moved to 23 Castlewood Avenue, Rathmines. The novel, *Ulysses*, was set in Dublin in 1904 and the centenary was celebrated all over Dublin, including Brighton Square, as seen in this 2004 photo.

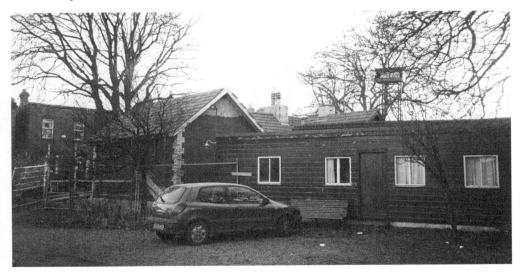

Brighton Square with the Spence Memorial Lodge, and small hall (the latter now used for art classes).

The original Spence Memorial Lodge in Brighton Square. (Courtesy of George Stuart)

Brighton Square looking south in more car-free days, 1969. (Courtesy of George Stuart)

Thoms Street Directory for 1894. Mash tuns were big vats or tubs used in brewing and distilling. (Courtesy of Dublin City Library & Archives)

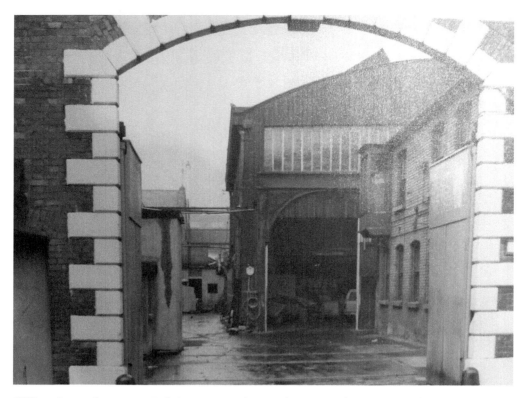

William Spence factory on Cork Street, around 1971. (Courtesy of George Stuart)

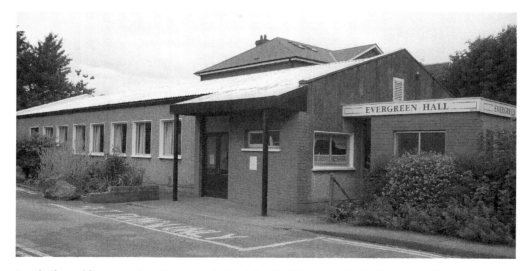

Beside the public car park in Terenure, behind the Health Centre, is the Evergreen Retirement Club for Terenure and surrounding districts, as seen in this 2013 photo. Glenpool Cottages and Glenpool Terrace were demolished to make way for the public car park.

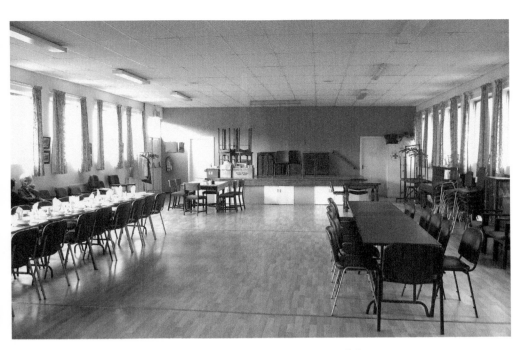

Three-course dinners are served every day in the Evergreen Club.

Sheelah Flatman, second from right in this early 1970s photo, was the driving force behind the founding of the Evergreen Club. (Courtesy of Norah Price, Evergreen Club)

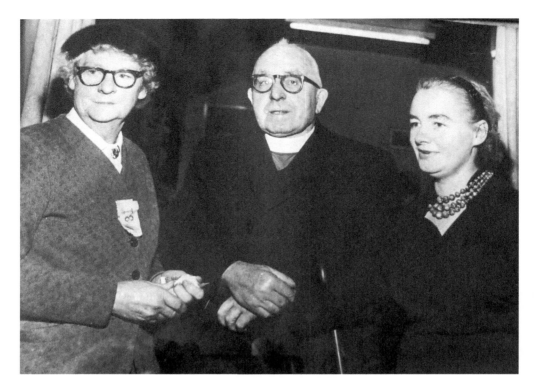

OPEN CLASSES —Continued	1st	2nd	3rd
12 Carnations ; Border, 3 vases, distinct, 3 blooms in each vase	10/-	7/-	5/-
13 Carnations ; Tree, 3 vases, distinct, 3 blooms in each vase	10/-	7/-	5/-
14 Pansies ; 6 vases, at least 4 varieties, 3 blooms in each vase	5/-	4/-	3/-
15 Violas ; 6 vases, at least 4 varieties, 3 blooms in each vase	5/-	4/-	3/-
16 Antirrhinums; 6 vases in at least 3 distinct colours, 3 spikes of similar colours in each vase	5/-	4/-	3/-
17 Pelargoniums ; Zonal, box of 12 trusses	10/-	7/-	5/-
18 Begonias ; Double Tuberous, box of 6 blooms	10/-	7/-	5/-
19 Begonias; Single Tuberous, box of 6 blooms	10/-	7/-	5/-
20 Annuals ; 6 vases, distinct kinds	7/-	5/-	3/-
21 One Pot of Trailing Lobelia	5/-	4/-	3/-
22 Plants in bloom, 6 pots, distinct kinds, pots about 8 inches	10/-	7/-	5/-
23 Ferns and Foliage Plants ; 3 pots of each Distinct varieties. Pots of about 8 inches	10/-	7/-	5/-

ROSES.

24 Roses ; box of 12 blooms, distinct	20/-	10/-	7/-
25 Roses ; box of 6 blooms, at least 4 varieties	10/-	7/-	5/
26 Roses; box of 6 blooms, any one dark variety	10/-	7/-	5/-
27 Roses; box of 6 blooms, any one light variety	10/-	7/-	5/-
28 Roses; Ramblers, 4 vases at least 3 varieties	10/-	7/-	5/-
29 Roses ; Single, not more than 1 row of petals one vase, one variety (Ramblers excluded)	5/-	4/-	3/-
30 Roses; basket of, arranged for effect Need not be grown by Competitor	10/-	6/-	4/-
31 Basket of Flowers, arranged for effect Need not be grown by Competitor	10/-	6/-	4/-

SWEET PEAS.

32 Sweet Peas ; 12 bunches, distinct Own foliage only	20/-	10/-	7/-
33 Sweet Peas ; 6 bunches, distinct Own foliage only	10/-	7/-	5/-
34 Sweet Peas ; 3 bunches, distinct Own foliage only	7/-	5/-	4/-

Please read Exhibition Rules.

Above Father Joseph Union, parish priest of St Joseph's from 1953, attended some Evergreen Club events. (Courtesy of Norah Price, Evergreen Club)

Left Terenure Horticultural Society prize list from the 1920s. Every year a competition was held in the grounds of Ashfield House, just south of Rathfarnham Bridge. The house is now owned by a security company, having been refurbished in recent years. (Courtesy of the National Library of Ireland)

FRUIT—Continued.

		1st	2nd	3rd
59	Currants; plate of black	5/-	4/-	3/-
60	Currants; plate of red, as grown on stem	5/-	4/-	3/-
61	Gooseberries; plate of, any one red variety	5/-	4/-	3/
62	Gooseberries; plate of, any one green variety	5/-	4/-	3/-
63	Gooseberries; plate of, any one amber variety	5/-	4/-	3/-
64	Loganberries; plate of	5/-	4/-	3/-

Special Prize (£1) for Exhibitor scoring the highest aggregate in above Fruit and Vegetable Classes.

Messrs. Wm. Watson & Sons, Ltd., Killiney Nurseries, Killiney, Co. Dublin, will give Six named Bush Apple Trees to Winner of most points in Fruit Classes, the Winner to apply for the Trees in November, 1925, enclosing the Hon. Secretary's Certificate.

First, 4 points; Second, 3 points; Third, 2 points; H.C., 1 point

Home Industries Section.

Entry Fee, 1/-. Members, 6d.

		1st	2nd	3rd
65	Eggs; hen, (white) one dozen	5/-	4/-	3/-
66	Eggs; hen (brown), one dozen	5/-	4/-	3/-
67	Butter; about 1 lb.	5/-	4/-	3/-
68	Soda Bread; brown, about 2 lbs.	5/-	4/-	3/-
69	Soda Bread; white, about 2 lbs.	5/-	4/-	3/
70	Cake, Fruit, about 2 lbs.	7/-	5/-	4/-
71	Cake, Plain, about 2 lbs.	7/-	5/-	4/-
72	Honey; 6 sections	7/-	5/-	4/-
73	Crochet; one specimen	10/-	5/-	4/-
*74	Crochet, for School Children	5/-	4/-	3/-
*75	Darning a natural hole in woollen or cotton article	5/-	4/-	3/-
*76	A child's garment	5/-	4/-	3/-
	* These Three Classes are for School Children only. Entry Fee 3d.			
77	1 pair knitted socks	5/-	4/-	3/-

Terenure Horticultural Society prizes in the 1920s. (Courtesy of the National Library of Ireland)

4

BUSINESS

PUBLIC HOUSES

'Flood's' started as a small shop around 1860, and their three premises seem to have been re-built and amalgamated around 1880. They were big grocers and spirit merchants until the late 1960s. An auctioneers brochure in 1971 refers to a bar and lounge, grocery shop, fruit shop, and also a chemist shop fronting on to Terenure Road North (the premises effectively wrapped around the National Bank). Then Blades Bar took over, and now Brady's has the premises.

The 'Eagle House' is a nineteenth-century pub, acquired by the Vaughans in 1916. In 1865, Margaret T. Murray, tea and wine merchant, is listed as the occupier (one of the Murrays later married John Joyce, with one of their offspring being the author, James Joyce).

Brady's Wine Merchants cum Royal Hotel can be seen on postcards around 1900, but the building seems to date from the 1850s, becoming Flood's Royal Hotel around 1906, then The National Bank from 1935, and is now Cronin Accountants. Thoms Street Directory for 1865 lists Isaac Cole as the occupier of the Royal Hotel, tavern, parcel office, waiting room for omnibus (stage coach), and garrison billiard rooms.

BANKS

The Royal Bank of Ireland (which took over Shaws Bank in 1837 – Shaw lived in Bushy Park House) opened their new premises at the south-east corner of Terenure crossroads in 1912, to a design by O'Callaghan & Webb, and built by S.H. Bolton & Sons of Rathmines. There was previously a post office here. The best of materials were used for the bank, including Ballyknockan granite on the ground floor elevations, Portmarnock red brick for the upper floors, internal walls of Mount Argus stock brick, oak counters and panelling in the banking hall, including terrazzo and woodblock flooring, and white enamelled brickwork for the basement vaults. The bank manager resided in the spacious rooms upstairs. In the mid-1960s, they amalgamated with the Provincial Bank of Ireland and the Munster & Leinster Bank, to form Allied Irish Bank (now called AIB), and soon afterwards built a new premises at 12 Rathfarnham

Road. J.P. & M. Doyle, auctioneers, took over the original premises, which still features quality joinery, cornices and woodblock flooring. Recently, the AIB branch closed, and at the time of writing awaits a new use.

Bank of Ireland then arrived in 1933, opening their iconic branch at the south-west corner of the crossroads, designed by Millar & Symes. Artificial stone and coloured plaster give the building a Mexican look.

The National Bank Ltd acquired the landmark Flood's Royal Hotel, Parcel Office, and Tram Waiting Rooms, at 142 Terenure Road North, refitted the building, and re-opened in March 1935. They were taken over and rebranded by Bank of Ireland in 1975 – resulting in two branches of the same bank in Terenure! This handsome corner building is now occupied by Cronin Accountants.

Northern Bank built a branch in 1975 at 102-104 Terenure Road North, then Sayers Restaurant traded, and nowadays Brambles Restaurant occupies the premises. Prior to this, Elm Park Terrace (98-104 Terenure Road North), comprising four two-storey houses, was demolished.

Ulster Bank is a recent arrival, right beside St Joseph's church.

TERENURE LAUNDRY CO.

Henry Waring started the Terenure Laundry in 1904, in his villa-style house called 'Frankfort'. By the 1930s, various extensions had increased the premises to about 1,500 square metres (16,000 square feet) plus offices of about 140m² (1,500 square feet). In the mid-1960s the series of double-pitched roofs over the south half were replaced with a higher northlight-type roof on steel trusses, incorporating the space occupied by the old house, but retaining the front battlemented wall. A caretaker occupied a wing on the south side of the original house. The laundry had a Receiving Office at 96 Harcourt Street.

Waring died in 1913, and was replaced by William J. Simpson as the manager from about 1920 to 1950, and he was one of the elders of Rathgar Presbyterian church.

Along with all other Dublin laundries, Terenure went on strike in 1945, which lasted for fourteen weeks, but succeeded in gaining two-weeks paid annual holidays for all Irish workers, men and women, in all sectors. The strike was organised by the Irish Women Workers Union (most laundry workers were women and young girls), and the Terenure Laundry shop-steward, May Clifford, was at the forefront of the strike.

The laundry closed in the early 1970s, and shortly afterwards the *Sunday World* newspaper and their printing presses took over the extensive premises, building a new three-storey office block facing Rathfarnham Road (in front of the original 'Frankfort' house).

After the *Sunday World* moved, the German-owned Lidl discount supermarket was built on the cleared site, opening in December 2013.

GLENABBEY HOSIERY

In 1940, Henry Keogh & Co. Ltd, knitting factory, is listed at 24A Rathfarnham Road, to the south of the Terenure Laundry. In 1965, Eve of Dublin Ltd had taken over the underwear business, and then Glen Abbey was listed from 1975. Langdon & Sons, wholesale textiles, were in occupation in 1980. Now the Terenure Business Park occupies the old factory buildings in Beechlawn Way.

CLASSIC CINEMA

The Flood family (publicans and grocers) started Sundrive Cinema Co. Ltd in 1935, building the Sundrive Cinema in Kimmage that year, the Classic in 1938, and the Kenilworth in Harolds Cross in 1953. When the Terenure Classic closed in 1976, the manager, Albert Kelly, bought the name and transferred it to the Kenilworth Cinema, which he purchased. The Classic in Harolds Cross closed in 2003 and was recently demolished.

The 750-seater Terenure Classic opened with *I'll take Romance*, starring Grace Moore, as the main film. Escape to *Witch Mountain* was the last main film in 1976. Albert Kelly introduced the cult film, *The Rocky Horror Picture Show* as a late show on Friday nights, and continued that tradition when he moved to Harolds Cross, resulting in a twenty-five-year run.

The original Classic in Terenure is now the Terenure Enterprise Centre, established in 1987, comprising thirty small businesses. The site, together with the library site behind on the Templeogue Road, was a tram terminus for the Blessington Steam Tramway up until 1933.

ELY MILL

Immediately to the south-west of Rathfarnham Bridge was a mill, shown on old Ordnance Survey maps as Ely Cloth Factory (John Henry Wellington Graham Loftus, Marquis of Ely, was the landlord). Richard Frizell's map of 1779 lists Widow Clifford as occupying a mill here, and shows a single-arch stone bridge, entitled Rathfarnham Bridge, over the River Dodder, with the area to the east of the bridge marked as The Strand.

The Pettigrew & Oulton Almanac of 1835 lists John Murray as a woollen manufacturer, in Ely Mills.

Griffiths Valuation in the 1840s shows Thomas Murray as the occupier of a Cloth Mill, and the Marquis of Ely as the landlord, on 6½ acres. Thoms Directory at the time recorded the employment of 100 workers. The waterwheel was powered by a head-race starting in Rathfarnham village, and the tail-race emptied into the River Dodder, a little to the east of The Big Bridge. The large mill pond acted as a store or cistern, especially when water would be scarce in the summertime.

The Dixon family operated as flour millers, as sub-tenants of Thomas Murray, from 1850, followed by Nixon/Nickson, and John Lennox, up to 1880, after which the mill is described in the Valuation books as 'Buildings all down'. Thereafter the land is occupied by John Tottenham.

The mill, and Ashfield House to the south, was sold by the Landed Estates Court, in 1875, on the instructions of John Loftus, Marquis of Ely. John Lennox occupies the seven-acre Flour Mill, at £59/pa, as the representative of Patrick Lambert, the original lessee in 1811. Joseph Callaghan occupies Plot 2, Thomas Moyers occupies Plot 3, and Mrs Sarah Tottenham occupies Ashfield House (which was previously called Cherry Tree House or Inn), on leases going back to 1770.

Rathfarnham Bridge was a little hamlet in itself, with various cottages and small businesses. For example, in 1835, Richard Callaghan is listed as a grocer and provision dealer, and the Callaghan family are still living in Dodder Cottage at later dates.

OTHER BUSINESS

To the north of Centra, at 'Mountain View', 122 Terenure Road North, there is a large vacant site, and a long two-storey house in the centre, which was William Kennys Dairy, and the source of milk for many families for miles around.

In the 1960s, Irish Engineering & Harbour Construction Co. (Irishenco), a major civil engineering company, operated from 62 Terenure Road North (to the south of the CYMS).

In the 1990s, Bagenall Fagan Motors was located where Eddie Rockets Restaurant is now (west of Cripps Shoes). There was a petrol station here in the 1970s.

Hilda White (*née* Fine) operated a kosher (Jewish) grocer's at 81 Terenure Road North from about 1960 to the 1980s. Today Supervalu in Churchtown has some kosher food.

The Cripps family started a shoe shop in St Augustine Street in 1903, then moved to Thomas Street, before opening another branch at 4 Terenure Place in 1962, where they are still trading.

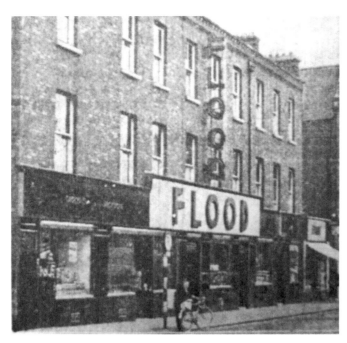

A 1969 view of Flood's grocery store (now Brady's pub). (Courtesy of the Irish Architectural Archives)

NICHOLAS FLOOD,

Wine Importer and Bonder, Tea Blender, Coffee Roaster, General Grocer, and Provision Merchant,

Flour, Oatmeal, Foodstuffs for Horses, Cattle, Fowl, Etc. Noted for the Superior Quality of Goods Stocked in all Departments.

SPECIALITIES—High-Class Teas, Coffees, Wines, Hams and Bacon, Creamery Butter, Etc.

3, 4, 5 & 6 Terenure Place.

Telephone No.—Rathmines 2. Second Line—Rathmines 540.

A 1929 advertisement for Flood's grocers. (Courtesy of the Irish Architectural Archives)

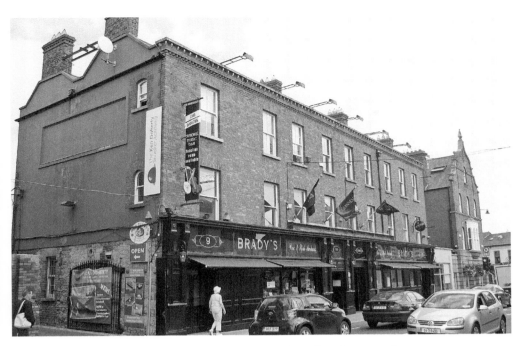

Present-day Brady's pub. This was originally Flood's pub and grocery shop.

Slatterys Terenure House on Terenure Road North was a small pub in the 1950s, expanding in the 1960s, but is now a Tesco Metro supermarket. Quinlans was the last publican, and covered the front with lovely murals.

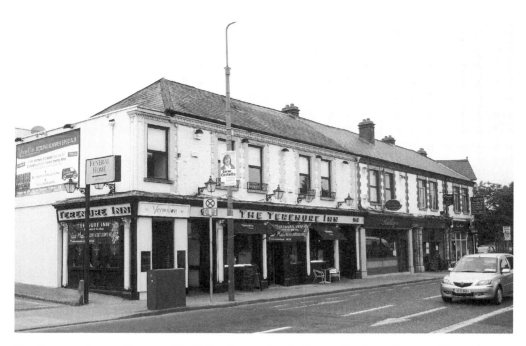

The Terenure Inn on Terenure North Road, opposite the former Garda station, was Norton's Stores in the 1950s, and is still going strong.

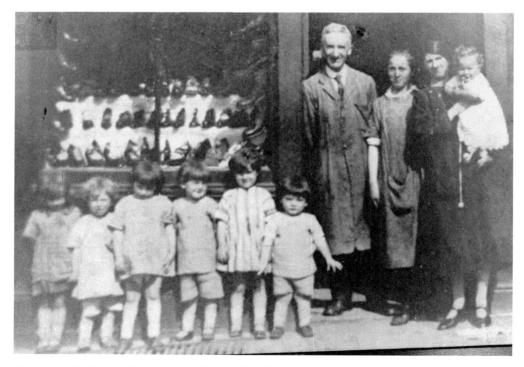

The Cripps family. outside their shoe shop in The Liberties, 1925. (Courtesy of Cripps)

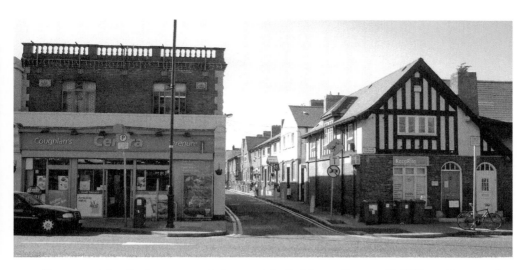

The present-day Centra supermarket was originally Magees Grocers. H. Williams Supermarket set up in 1960, and was taken over by Supervalu, and now Centra Supermarket. Yewland Terrace on the right was built in 1909 by South Dublin Rural District Council, replacing more numerous tiny cottages, called Howards Lane and Healys Lane/Farrells Cottages.

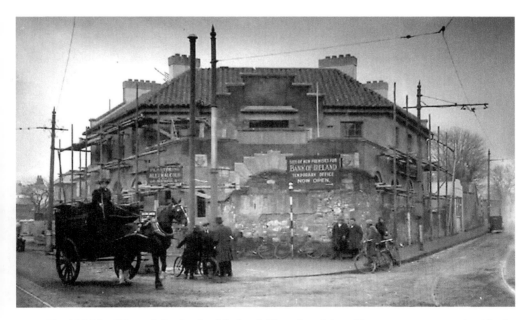

The 1931 building of the Bank of Ireland. Note that Cripps Shoes terrace was not yet built. (Courtesy of the Bank of Ireland)

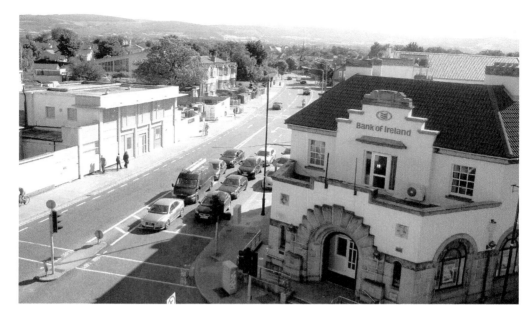

Present view of the Bank of Ireland. To the left is the Allied Irish Bank, now closed. Terenure Synagogue is just visible behind this.

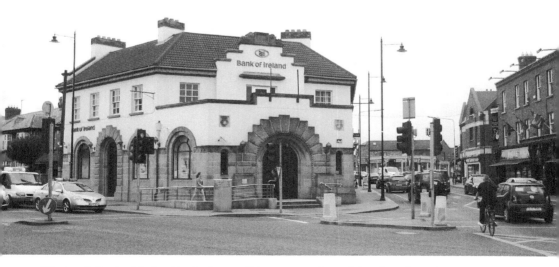

The iconic Bank of Ireland in the heart of Terenure, with Brady's pub to the right. Between the latter two is Bill Sheehan Motors, the last of the original 'Roundtown' cottages.

The Allied Irish Bank now stands empty, while the German-owned Lidl are building a new discount supermarket on the site of Terenure Laundry (and recently the *Sunday World* newspaper site).

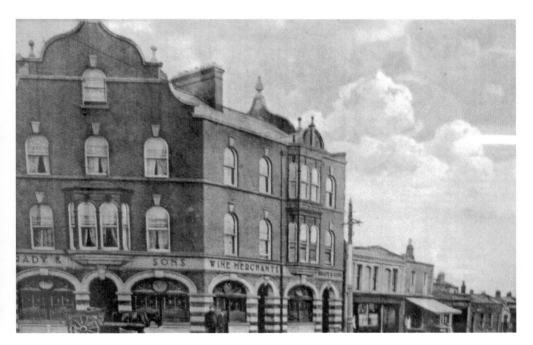

Postcard from around 1900. This is now Cronin & Co., accountants, but was previously the National Bank, and before that the Royal Hotel. (Courtesy of Cronin & Co., Accountants)

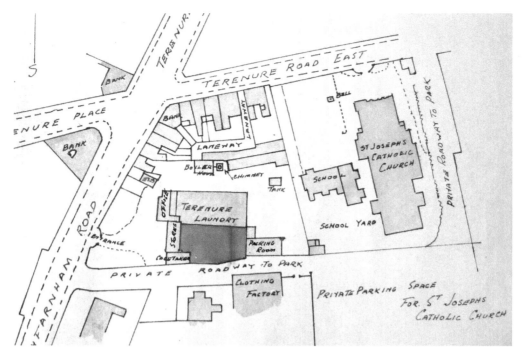

A 1964 plan of Terenure Laundry. The darker south part was about to be re-roofed. (Mc Donnell & Dixon drawings, courtesy of Irish Architectural Archive)

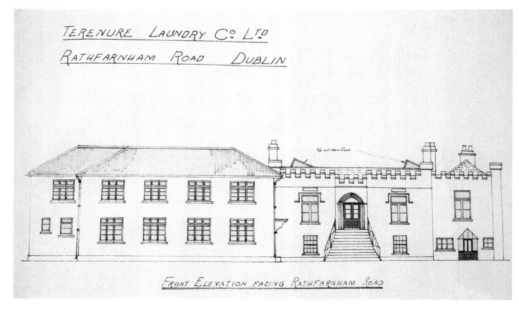

Terenure Laundry was built on the site of 'Frankfort', and for years the house was retained as offices and caretaker accommodation. (Mc Donnell & Dixon drawings, courtesy of Irish Architectural Archive)

A 1964 proposal to re-roof the south part of Terenure Laundry. (Mc Donnell & Dixon drawings, courtesy of Irish Architectural Archive)

A 1964 layout of Terenure Laundry. (Mc Donnell & Dixon drawings, courtesy of Irish Architectural Archive)

A 1961 letter showing that laundry wage rates were about £4 15s for those over the age of 18. (Courtesy of Irish Labour History Museum)

TERENURE LAUNDRY CO. LTD.

The following Rates of Pay will apply from and on

Friday 7th April, 1961.

Hr. (40 Hrs).

14 years	40/-
14½ "	45/-
15 "	50/-
15½ "	55/-
16 "	65/-
16½ "	70/-
17 "	76/8
17½ "	83/5
18 "	95/-

Incurred Dec 1961

Pending the current claim for a reduction in the adult working week below 45 hours, workers on the 97/- rate will be paid a Bonus of 3/- for a 45 hour week.

Any worker entitled to a higher rate under the Trade Union Agreement will be paid at the higher rate.

Workers of 18 years and over with no previous laundry experience will be paid 90/- for a period not exceeding 6 months.

Irish Women Workers Union records for Terenure Laundry, 1941. (Courtesy of Irish Labour History Museum)

Terenure Laundry Co., Limited,

Terenure, Co. Dublin.

16th.March,1950.

The Secretary,
Irish Women Workers' Union,
48,Fleet Street,
Dublin.

Dear Miss Chenevix,

In reply to your letter of
March 14th. the hours of employment of members
of our Staff under 18 years of age are within
those permitted by the Conditions of Employment
Act and in accordance with the terms of our
agreement.

I hope that after our telephone conversation
you will agree that we have also borne in mind
the spirit of the Act.

Yours truly,

J. A. Simpson.

Asst.Managing Director.

Terenure Laundry correspondence with the Irish Women Workers Union from 1960.
(Courtesy of Irish Labour History Museum)

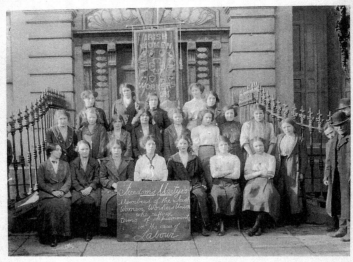

IRISH WOMEN WORKERS' UNION
1911-1984

... ALL WE ASK FOR IS JUST SHORTER HOURS, BETTER PAY THAN THE SCANDALOUS LIMIT NOW EXISTING AND CONDITIONS OF LABOUR BEFITTING A HUMAN BEING
- IWWU FOUNDER MEMBER DELIA LARKIN

AT ITS PEAK THE IWWU ORGANISED ABOUT 70,000 WOMEN, INCLUDING BOOKBINDERS, CONTRACT CLEANERS, LAUNDRY, PRINT AND ELECTRONIC WORKERS.

Outside the laundry we put up a fight
For a fortnight's holiday
They said we'd have to strike
So we keep marching up and down,
As we nearly did for half a crown
We are a fighting people
Who cannot be kept down

IN 1945, WOMEN LAUNDRY WORKERS SANG THIS SONG ON THE PICKET LINES AFTER THEY WENT ON STRIKE TO WIN TWO WEEKS ANNUAL PAID HOLIDAYS. NO ORGANISED MALE WORKERS HAD PREVIOUSLY DEMANDED THIS. THE WOMEN WON THAT RIGHT FOR ALL WORKERS.

IWWU Commemorative Committee, March 8, 2013

This plaque was erected on Liberty Hall in 2013 to commemorate the 1913 Dublin Lockout. The Irish Women Workers Union (IWWU) was founded in Dublin in 1911 by Trade Unionis, Jim Larkin, and his sister, Delia Larkin, with assistance from Countess Markievitz (*née* Gore-Booth, of Lissadell Hall, Sligo). They were affiliated to the Irish Transport and General Workers Union (ITGWU), based in Liberty Hall on Eden Quay, where the photo on the plaque was taken in 1914, near the end of the 1913 Lockout. The present Liberty Hall skyscraper stands on the same site. The IWWU were the organisers of the famous 1945 strike of Dublin laundries (where working conditions for girls and women were very poor), resulting in workers, both men and women, in all industries, getting a second week's paid holiday – before that, workers only had one week's holiday.

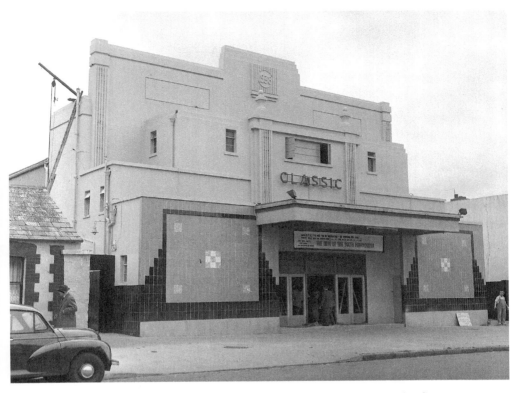

The Classic cinema in its heyday. (Courtesy of the National Library of Ireland)

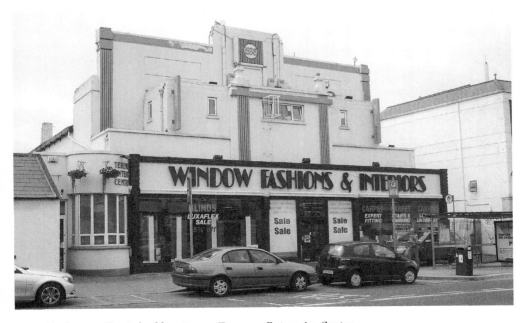

The former Classic building is now Terenure Enterprise Centre.

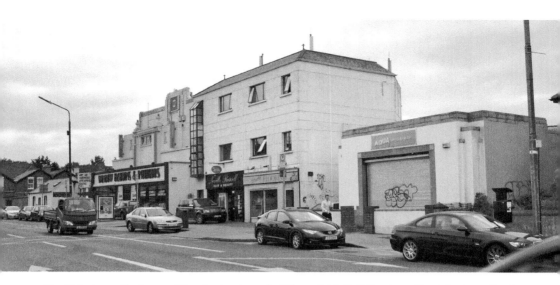

The Telephone Exchange. The single-storey building at 11 Rathfarnham Road (just north of Terenure Enterprise Centre) was built around 1928 for the former Department of Posts and Telegraphs, and sold to Cablelink/ntl in 1986. It was sold again in 2004. The original ground lease from 1920 is between Sir Frederick Shaw and Georgina Flood of Terenure Place. The new Eircom Exchange is now behind the present Garda Station.

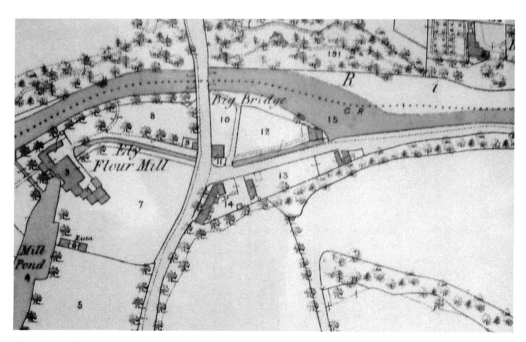

Ely Flour Mill was to the south-west of Rathfarnham Bridge in the 1860s. Note the mill pond storing water from the head race, which was taken off the River Dodder higher up in Rathfarnham. The water flowed under the mill, powering the waterwheel, and discharged via a tail race into the Dodder to the east of Rathfarnham Bridge. (Courtesy of the National Library of Ireland)

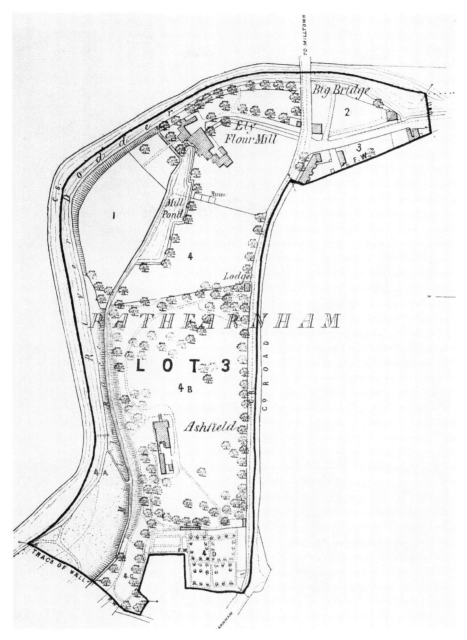

The combined investment properties of Ely Flour Mill and Ashfield House were sold on behalf of the Marquis of Ely (Loftus) in 1875 by the Landed Estates Court. This 1875 estate map gives a good indication of the layout of adjoining properties. Ashfield House is still in use today. (Courtesy of the National Library of Ireland)

An advert for Brown & Polson (Knorr), 1929. This company built their premises on Mount Tallant Avenue, beside the entrance to Clarnico Murray sweet factory, in the 1930s. They made cornflower, semolina, baking powder, etc. The building was taken over in 1957 by Milofsky & Sons, Jewish furniture makers, who now trade there under the name Woodworkers & Hobbies Supply Centre. (Courtesy of the National Library of Ireland)

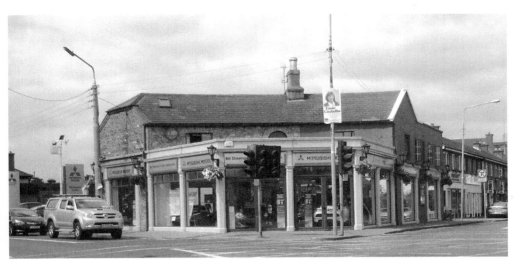

This car dealer occupies the last of the 1801 cottages named 'Roundtown'.

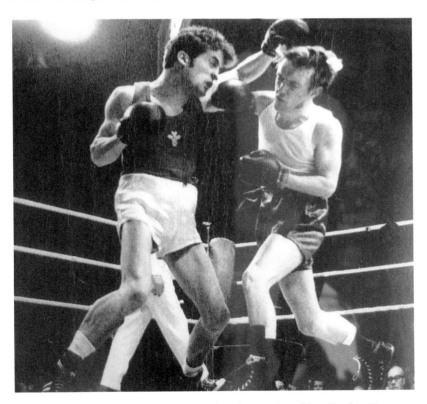

Mick Dowling, boxer, has a sports shop beside CYMS, and has lived in Terenure for decades. This photo shows Mick Dowling versus Gerry Jordan in the National Senior Championship, in the National Stadium on the South Circular Road, in 1969. (Courtesy of Mick Dowling)

ROUNDTOWN.

ROUNDTOWN ROAD, from Harold's Cross.

Joseph Hamilton, grocer and provision dealer
Michael M'Quirk, dairy
Patrick Dunn, tailor, and Exchequer-street
William Byrne, dairy
Mrs. Findlay, Cruz de Campo
Misses Archbold
Mr. Thomas Rogers, Ellenea Villa
Mrs. Hughes, do.
Thomas Smyth, jaunting car owner

ELM-VILLE COTTAGES.

Mr. Arthur Green
Mr. Henry Greaves
William Collins, esq.
Robert F. Murphy, esq. surgeon
Mr. Andrew Brien
James Thompson, esq. Elm-ville
Henry Odlum, esq. do.
John Renshaw, esq. do.
Mr. Allen Jackson, corner of Rathgar Avenue
Joseph Walsh, esq. Arbutus Lodge, Mount
 Tallant Avenue
Emanuel Hutcheson Orpen, esq. attorney
William Shine, esq. Willow-mount
Patrick Whelan, esq.
Philip Cornwall, esq. Ash-field
Philip Smith, lime works, Roundtown quarry

ROUNDTOWN.

John Dodd, esq. and Sackville-street
Edward Tigh, grocer and provision dealer
Samuel Ball, jeweller, Dodd's Buildings
James Rooney, do.
Jas. Sharp, machine maker & millwright, do.
Thomas Smyth, paper maker, do.

ROUNDTOWN—continued.

Mr. J. R. Frazer, John-ville seminary
Thomas Ashley, esq. Glenpool-place
Patrick Sheridan, house painter and glazier
Mr. Edward Stubbs
—— M'Dermott, slater
Mrs. Robinson
Samuel Dunoyer, carpenter and builder
Mr. Edwin Parnell
Mr. George Spedding, officer of excise
Mr. William M'Hugh, Jubilee Cottage
Patrick Fullam, esq. attorney, and 91 Capel-st.
P. O'Neill, boot and shoemaker
James Howard, provision dealer
Michael Howlet, boot and shoemaker
Bryan O'Reilly, do.
George Draper, esq. Montevidea
Patrick Beaghan, grocer
James Howard, Roundtown bakery
Andrew Smyth, tavern-keeper
Thomas Molloy, grocer and provision dealer
John Mahon, tailor, and post-office keeper
Elizabeth Dowling, grocer and provision dealer
John Dempsey, harness maker
Henry Carroll, smith
William Kelly, smith
Laurence Higgins, provision dealer
Patrick Casey, vintner
Jane Cavenagh, Roundtown bakery
Mich. Somers, victualler, & jaunting car owner
Mrs. Shaw
Police Station, No. 1
Mr. Charles Spear
Mr. Robert Jackson, Woodbine Cottage
Mr. Busby
Mr. Thomas Atkinson
Henry Price, tailor

Pettigrew & Oulton street directory, 1835. (Courtesy of Dublin City Library & Archives)

5

TRANSPORT

ELECTRIC TRAM

Prior to the trams, Dublin had horse-drawn omnibuses. We know that the omnibus served Roundtown/Terenure in the 1840s, and probably earlier. Horse-drawn trams, running on tracks at a gauge of 5 feet 3 inches, initially with open-topped upper decks, were introduced to Dublin in 1872. The Dublin Tramway Company opened its first line to Rathgar that same year, initially running from College Green, and then between Nelsons Pillar (now The Spire) and Terenure, to the depot opposite St Joseph's chapel-of-ease. In 1879 The Dublin Central Tramways Company opened a line, from College Green via Harolds Cross, to Terenure, extending it to Nelsons Pillar and Rathfarnham in 1883. This company had a small depot immediately to the south of the present Terenure Enterprise Centre. Such depots were used to shelter the single-carriage trams at night, and also to stable the many horses – two were usually needed for each tram. The line terminated outside Rathfarnham Courthouse, but there was no depot there. In 1896, the three main tram companies amalgamated into the Dublin United Tramways Company (1896) Ltd, under the chairmanship of William Martin Murphy, who was to feature negatively in the notorious 1913 Dublin Lockout. From 1903 to 1918, the symbol for the Harolds Cross route was a green Maltese cross, while that of the Rathgar line was a red triangle, after which the No. 16 and No. 15 were used respectively.

The Dublin trams were electrified from 1896 onwards, including those on the Terenure routes in 1899.

Private wheeled buses appeared from the 1920s onwards and competed with the tracked trams. The original trams operated every three minutes, and achieved speeds of around 6mph.

Coras Iompair Eireann (CIE) was formed in 1945, taking over the Dublin United Transport Co. and the Great Southern Railway.

The last No. 16 tram ran in May 1939, while the No. 15 carried on until the last tram on 31 October 1948. Thereafter, the depot opposite St Joseph's church became a graveyard, where many trams were dismantled and sold for scrap metal. In later years, Castrol Oils had a depot here, and then Charles Nolan Electrical was

in possession. The *Star* newspaper occupied the south-east wing for a few years in the 1990s before moving to a new office block beside the Terenure Sports Club/CYMS. Faulks Lighting recently occupied the former tram ticket office. At the time of writing, the depot is due to be demolished to make way for a German-owned Aldi discount supermarket.

Many tram carriages were made in Spa Works, Goldenbridge, near Inchicore Railway Works. Some people may remember the knifeboard seating on top – where the customers sat 'back to back'.

The only trace of the Rathfarnham Road depot is the north boundary wall of Cormac Terrace South (originally called Tramway Terrace), where the stables for the horses were probably located. After the tramway closed in the 1930s, Cormac Terrace North cottages were built.

BLESSINGTON STEAM TRAMWAY

The Dublin and Blessington Steam Tramway ran between Terenure and Blessington, a journey of 15½ miles, commencing on 1 August 1888. The Terenure depot was on the Templeogue Road, where the Library and Terenure Enterprise Centre are now located. Moira House on Rathfarnham Road was their adjoining headquarters. There was a bigger depot in nearby Templeogue village, to the south of the Templeogue Inn, where Templeogue Tennis Club is now located.

There were twenty-three intermediate stops between Terenure and Blessington, and six laybys (loops). The stops/ticket booths were often at rural pubs. The loops were needed because there was only a single line, usually on the left-hand side of the road, and to avoid head-on collisions between two trams travelling on the up and down journey, one tram had to pull in at regular intervals. Not surprisingly, there were occasional head-on collisions and derailments. In the initial years, the company had six engines, four third-class carriages, one first-class carriage, five mixed carriages (first and third class), four open wagons, four cattle wagons and two covered wagons. The engine usually pulled two dark-green carriages, both double-decker, with open sides on the upper deck and open spiral staircases at each end, all under the control of a driver and a conductor. The journey to Blessington usually took 1½ hours, travelling at about 40mph on the flat, and about 5mph on hills, especially between the Embankment and Crooksling Sanitorium.

The service was extended to Poulaphouca in 1895, by the Blessington and Poulaphouca Steam Tramway.

When rural passengers reached Terenure, they could transfer to the frequent trams into the city. In addition, the Dublin United Tramway Company allowed the Blessington goods wagons to continue into Dublin along the tram lines.

Because of the advent of buses, such as the Paragon Company, the steam tramway could not compete on fares, and was taken over for a few years by the two County Councils in 1927. The last steam tram ran on 31 December 1932, although the Poulaphouca extension closed in 1927. Hammond Lane foundry bought the tracks and carriages for scrap, and used the Templeogue depot as a dismantling yard.

The tramway terminus in Terenure, with frontages to both the Templeogue Road and the Rathfarnham Road, is now the site of the Library on the former side, and the Terenure Enterprise Centre on the latter side (this was originally the Classic cinema).

The Templeogue Inn is marked on nineteenth-century maps, and is still going strong. Rural pubs in the past were often used as temporary overnight mortuaries,

The Morgue pub is still in Templeogue village, and its name, and the public clock, commemorates the Dublin and Blessington Steam Tramway.

especially on main roads. In Templeogue, the steam tramway was the cause of many accidental deaths, and in time the Templeogue Inn was used as the local morgue (mortuary). In fact, local wags nicknamed the route to Blessington as 'the longest graveyard in Ireland'. To this day, the pub has been unofficially called The Morgue, and in recent years the owner has in fact officially renamed the pub as such. In 1990, the owner erected a huge external clock, complete with a model steam tram running around the top.

The former No. 15 tram depot (rear centre of photo) is still opposite St Joseph's church. (Courtesy of Mannings)

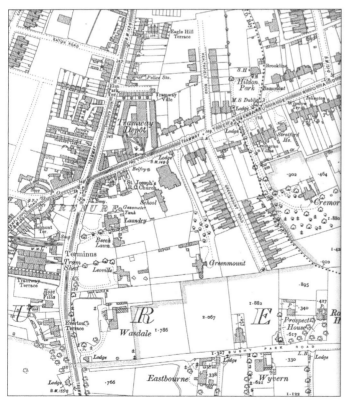

Ordnance Survey map, 1907. Note the Tramway Depot opposite St Joseph's church. On the Rathfarnham Road, the Tram Shed for the No. 16 Tram is visible, and also the Terminus for the Blessington Steam Tramway. Leoville was later demolished to make way for the synagogue. (Courtesy of Trinity College Map Library)

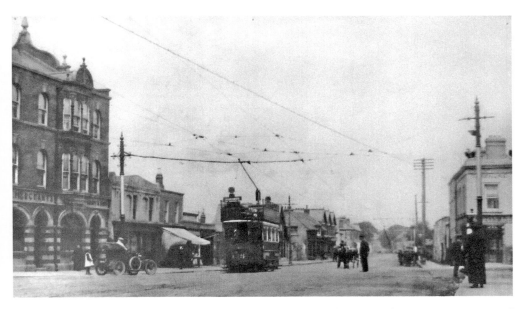

A 1900 postcard of Terenure crossroads. (Courtesy of the National Transport Museum of Ireland)

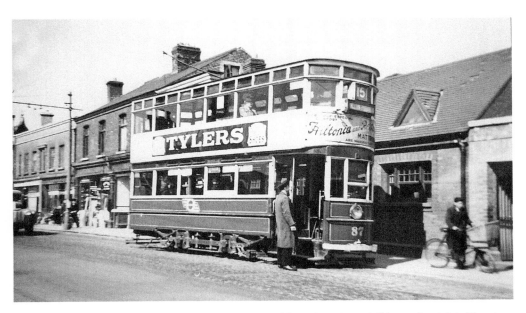

Terenure Road East in the 1940s. The 1943 public toilet is just visible on the right. (Courtesy of the National Transport Museum of Ireland)

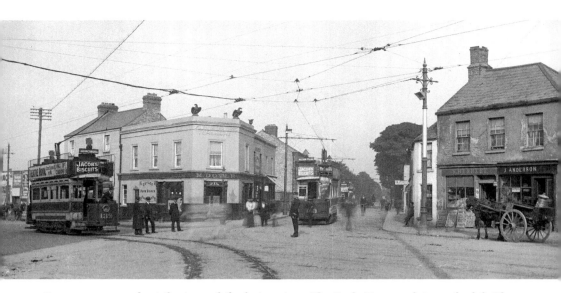

Terenure crossroads at the turn of the last century. The Eagle House pub is on the left. The building on the right was later rebuilt for the Royal Bank of Ireland, and is now J.P. & M. Doyle, Auctioneers. Notice the policeman on point duty in the middle of the road. (Courtesy of the National Library of Ireland)

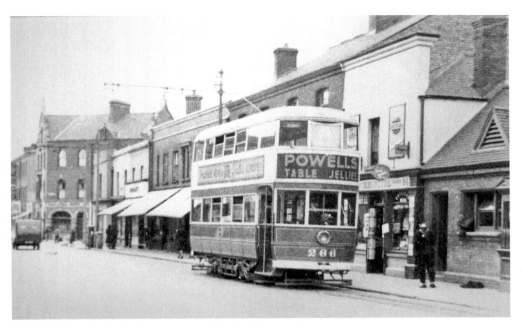

Terenure Road East in the 1940s. (Courtesy of the National Transport Museum of Ireland)

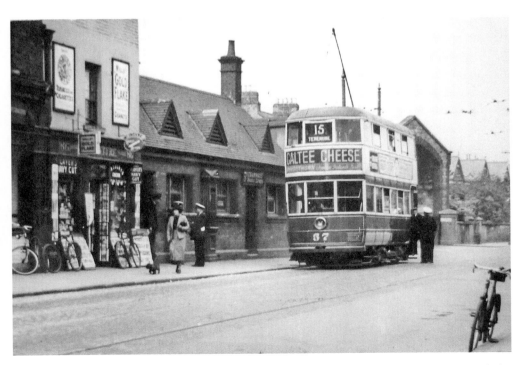

Terenure Road East looking east, outside the tram depot, in the 1940s. (Courtesy of the National Transport Museum of Ireland)

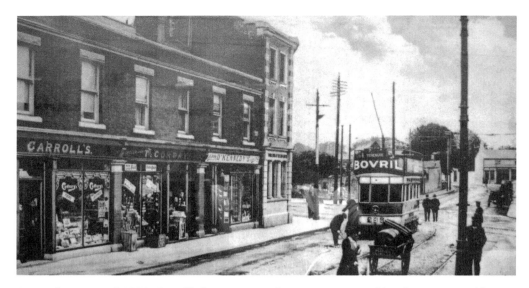

A view from around 1920. Carroll's famous sweet shop is now occupied by Sherry Fitzgerald, estate agents. The Bank of Ireland is not yet built. (Courtesy of the National Transport Museum of Ireland)

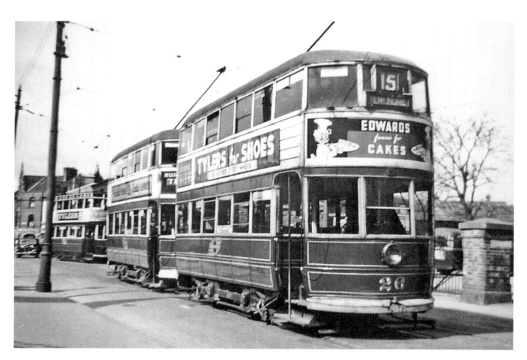

Trams queue up outside the depot on Terenure Road East in the 1940s. (Courtesy of the National Transport Museum of Ireland)

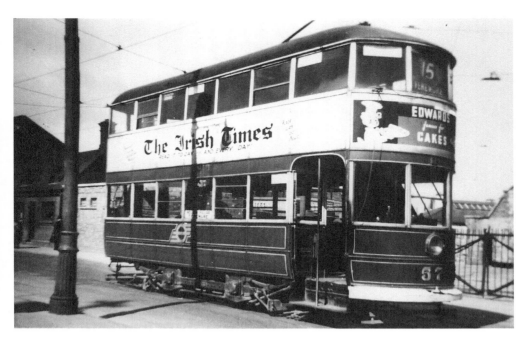

Outside Terenure Road East tram depot in the 1940s. (Courtesy of the National Transport Museum of Ireland)

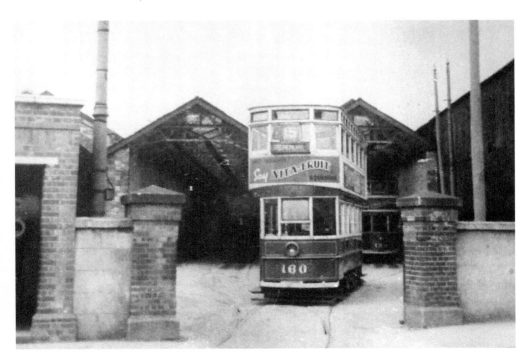

Terenure Road East tram depot in the 1940s. The public toilet is just visible on the left. (Courtesy of the National Transport Museum of Ireland)

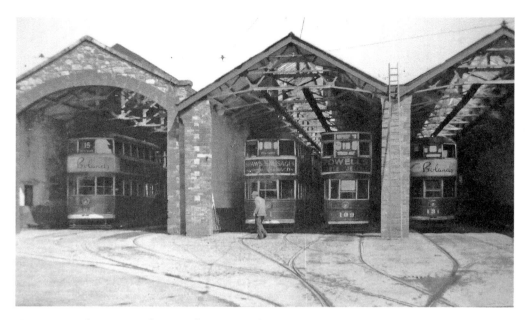

Terenure Road East tram depot in the 1940s. The open fronts were infilled with a wall and windows in the 1950s. The tram tracks were presumably removed. (Courtesy of the National Transport Museum of Ireland)

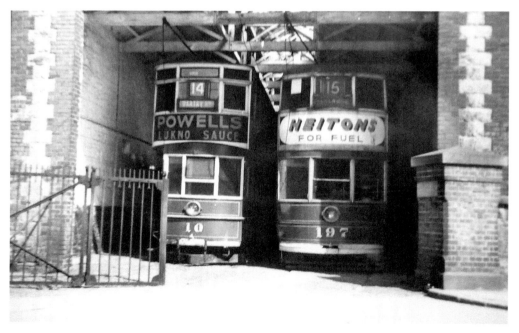

This part of Terenure Road East tram depot abutted the public road. (Courtesy of the National Transport Museum of Ireland)

In the 1990s the *Star* newspaper occupied the south-east wing of the former tram depot opposite St Joseph's church.

Recent view of the entrance to the former tram depot, with the south-east wing on the right, then the 1943 public toilets, and lastly the former ticket office.

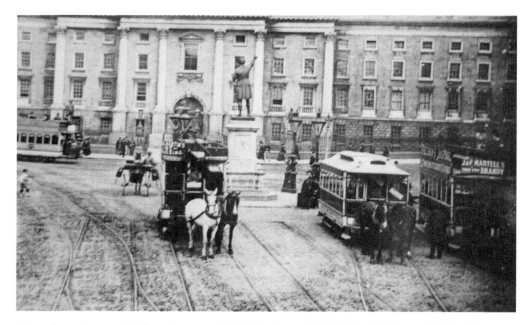

Horse-drawn trams at College Green, *c.* 1885. (Courtesy of the National Library of Ireland)

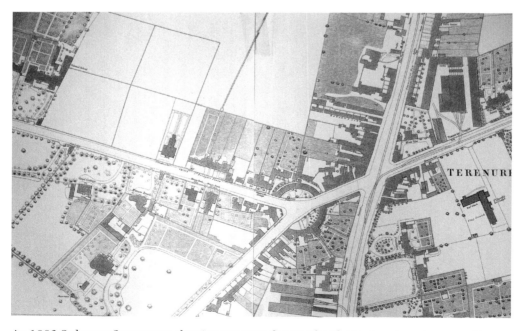

An 1882 Ordnance Survey map showing two tram depots. The Blessington steam tram would commence in 1888, with its terminus immediately north of the Rathfarnham Road tram depot. (Courtesy of Trinity College Map Library)

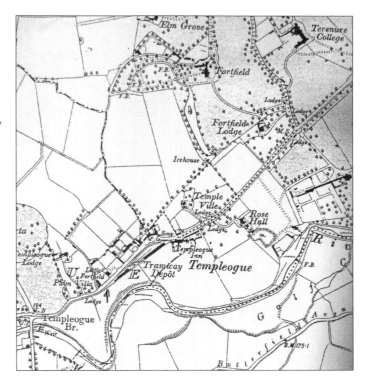

A 1912 Ordnance Survey map of Templeogue, showing the large Blessington steam tramway depot, beside the Templeogue Inn (nowadays called The Morgue). (Courtesy of Trinity College Map Library)

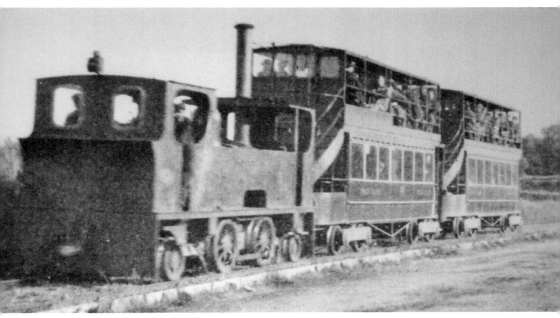

An early twentieth-century photo of a typical Blessington steam tram, running on a single track. (Courtesy of the National Transport Museum of Ireland)

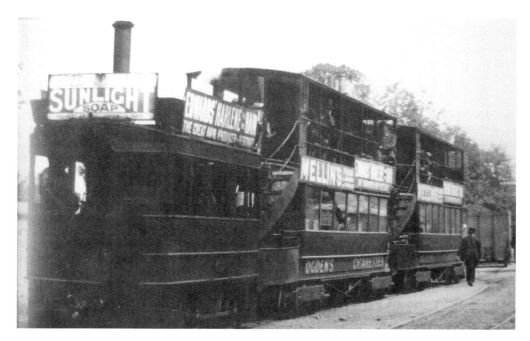

The top deck of the Blessington steam tram was open at the sides, which was not very pleasant during the winter, or when smoke from the engine chimney was blown backwards. (Courtesy of the National Transport Museum of Ireland)

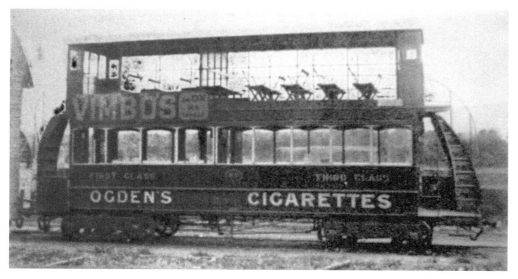

A typical Blessington steam tram. Note the partially exposed upper deck and the spiral stairs at each end for first and third class. (Courtesy of National Transport Museum of Ireland)

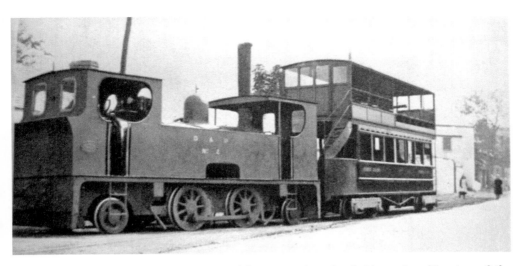

Note the D & B (Dublin & Blessington) letters on the side of this engine. (Courtesy of the
National Transport Museum of Ireland)

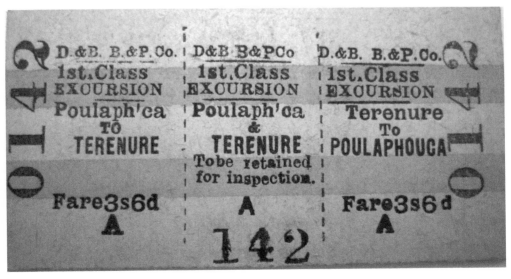

A typical tram ticket. D & B stands for Dublin & Blessington steam tramway, and B & P stands
for the other company which ran the line from Blessington to Poulaphouca. The expensive fare
of 3s 6d was only affordable by first-class passengers, although the third-class fare was cheaper
– there was no second class in that business! (Courtesy of the National Library of Ireland)

6

MISCELLANEOUS

GARDA

The Dublin Metropolitan Police (DMP) started officially in 1836, although the city had a police force going back as far as 1786, including Baronial Police (Barnies), and Bobbies or Peelers, the latter named after Sir Robert Peel, and even before that date, there were Watchmen. In rural areas, the Irish Constabulary were employed from 1822, and their name was changed to the Royal Irish Constabulary (RIC) in 1867. The RIC was disbanded in 1922, and the Garda Siochana formed, with the DMP joining them in 1925. Unlike the RIC, the DMP were un-armed.

In the Pettigrew & Oulton Almanac of 1835, Police Station No. 1 is listed for Roundtown, probably on the Templeogue Road, in the former toll house (people had to pay to travel up the new 1801 road) at the present corner of Fergus Road, since they are listed here in Griffiths Valuation of 1849.

The Dublin Metropolitan Police stayed on the Templeogue Road up to 1875. Rathfarnham village was rural and, instead of DMP, had a constabulary barracks (RIC).

Then, from 1875 to 1982, the DMP (Garda after 1925) were in 'Eglington' at 75 Terenure Road North, opposite The Terenure Inn, before moving to a new building on Terenure Road West opposite the Presentation Convent.

The 1901 Census shows Sergeant Thomas Richardson (Anglican) in charge of nine constables (seven were Catholic). In the 1911 Census, Sergeant Daniel Cronin (Catholic) is in charge of nine constables (one Anglican).

BOMBING DURING THE SECOND WORLD WAR

At around 6 a.m. on 2 January 1941, four bombs were accidentally dropped (presumably by Germany): two on an empty site in Laverna Grove, one at the rear of 49 Rathfarnham Road, occupied by Simon Lapedus, and another at the rear of Nos 25 and 27 Rathdown Park. Edward and Jane Plant, in No. 25, and their eleven-year-old daughter Jacqueline, were injured and treated in hospital. Louis Isaacson in No. 27 was not injured. The four bombs landed in the back gardens,

leaving 15 feet deep craters, but the explosions caused both houses in Rathdown Park to be badly damaged. Many other houses suffered minor damage.

That same day, bombing also occurred on the South Circular Road, near the Grenville Jewish Synagogue.

HOUSES

John A. Stringer built part of the iconic Rathdown Park estate, starting about 1928, although Murphy Building Contractors, and then Bailey Contractors, were involved at a later stage, the latter alongside Templeogue Road. Stringer also built the lovely redbrick houses in Healthfield Road, and the charming Rathfarnham Memorial Hall. He died in 1932.

LETTERBOXES

There are various items of 'street furniture' around Terenure, dating from the Victorian and Edwardian eras, including some pillar letterboxes. The cast-iron letterbox at the south-east corner of Eaton Square is an interesting example of an Edwardian item, made by McDowall Steven of Glasgow, displaying the King Edward VII insignia (the interwoven ER VII stands for Edward Rex the seventh, who reigned from 1901-1910). These boxes were painted red, prior to Ireland's Independence in 1922. There was a Post Office Receiver in Roundtown in the 1840s, and later a post office occupied the old building where J. P. & M. Doyle is now situated.

The 1801 toll house on the Templeogue Road only had two front windows, facing those travelling from the countryside into the city. Later the Dublin Metropolitan Police occupied the building, before moving to Terenure Road North in 1875.

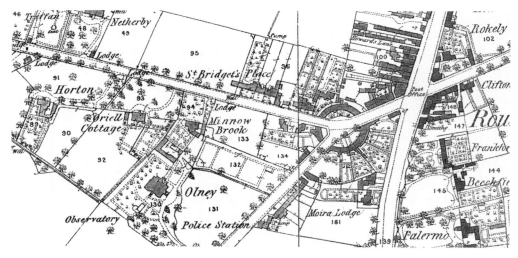

1865 Ordnance Survey map of Terenure, with the police station in the centre of the lower edge. The current Garda station is just to the north of Olney, on the site of Oriell Cottage. (Courtesy of Trinity College Map Library)

Floor plans of the former Garda Station on 75 Terenure Road North from the 1930s. There was a single cell in the back yard. Note the dormitory on the first floor. (Courtesy of the Office of Public Works)

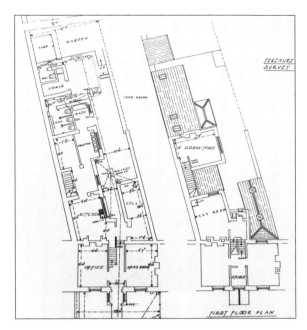

King Edward VII pillar letterbox at the corner of Eaton Square.

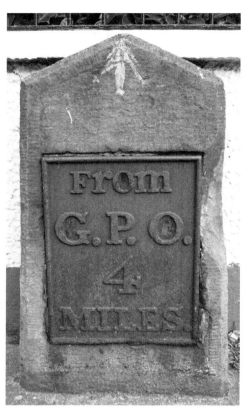

This 600mm high marker sits at the inner edge of the footpath opposite the entrance to Our Lady's School, and is shown on mid-nineteenth-century maps. The General Post Office was, and still is, in Sackville Street (now called O'Connell Street).

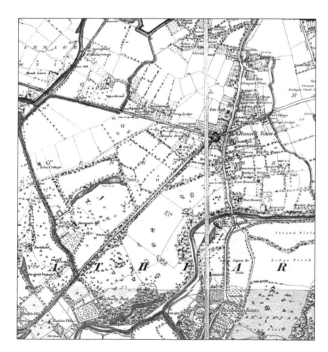

An 1837 Ordnance Survey map. (Courtesy of Trinity College Map Library)

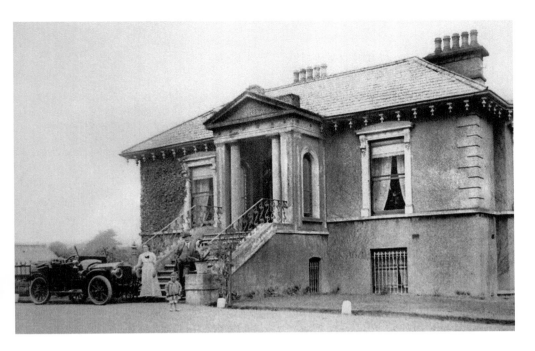

Clarnico Murray sweet factory was based in St Pancras Facory Works in Mount Tallant Avenue from the 1920s to the 1970s. This photo shows St Pancras House in 1915, occupied by the Lewis family, before it was demolished to make way for the factory. Note the Talbot-Darracq car. The empty factory now awaits the demolition ball. (Courtesy of Audrey Shiels)

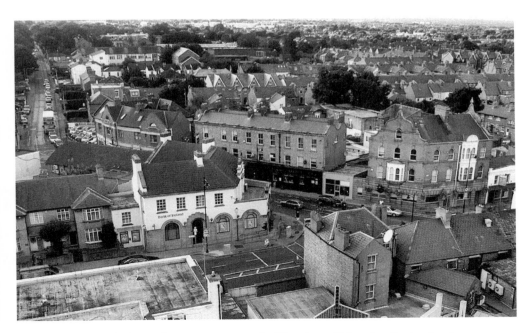

A recent aerial photo of Terenure crossroads. (Courtesy of Manning Contractors)

If you enjoyed this book, you may also be interested in...

Harold's Cross
JOE CURTIS

Today Harold's Cross is a bustling thoroughfare, and although it is now a suburb on the south side of Dublin, it was once akin to the best little town in Ireland, being completely self-sufficient, with schools, churches, shops, pubs and many farms and orchards. For its residents, it has a rich and varied history, which is beautifully captured in this book of archive photographs.

978 1 84588 702 5

Mount Merrion
JOE CURTIS

Mount Merrion lies on the south side of Dublin, 'between the mountains and the sea'. In 1711, the Fitzwilliam family walled the area to serve as their private country estate, and the 300th anniversary of this has sparked a new and enthusiastic interest in the history of the area. The early days of rustic open fields and tree-lined lanes are still in evidence, and this book by local historian and long-time Mount Merrion resident Joe Curtis continues that celebration.

978 1 84588 747 6

Castlebar
JOE CURTIS

Castlebar is the capital of County Mayo, and has long held its own courthouse, gaol, famine workhouse, asylum, hospital, four different churches, a convent and monastery, together with schools, an airport and every kind of business. In this book, author Joe Curtis captures a flavour of life in the town over time through a fascinating collection of images both old and new.

978 1 84588 790 2

Drogheda
JOE CURTIS

Illustrated with rare and archive images, this book is a record of the changing face of Drogheda itself. In this new book from historian Joe Curtis, the reader will relive much of this history, taking in the events and features that have shaped the development of Drogheda, and the landmarks that mark these changes, from the St Laurence Gate to the Millmount Martello Tower, from the old linen factory to the Lourdes Hospital.

978 1 84588 798 8

Visit our websites and discover thousands of other History Press books.

www.thehistorypress.co.uk